# A CELEBRATION OF
# JUDAISM
# IN ART

## IRENE KORN

SMITHMARK

*In loving memory of my grandmother, Sally Buchbinder, who shared with me her love of all things beautiful and the importance of tradition.*

Copyright © 1996 by Todtri Productions Limited.
All rights reserved.

This edition published in 1996 by
SMITHMARK Publishers,
a division of U.S. Media Holdings, Inc.,
16 East 32nd Street, New York, NY 10016.

SMITHMARK books are available for bulk purchase
for sales promotion and premium use.
For details write or call the manager of special sales,
SMITHMARK Publishers,
16 East 32nd Street, New York, NY 10016;
(212) 532-6600.

This book was designed and produced by
Todtri Productions Limited
P.O. Box 572, New York, NY 10116-0572
FAX: (212) 279-1241

*Printed and bound in Singapore*

Library of Congress Catalog Card Number 96-69002

ISBN 0-7651-9918-1

*Author:* Irene Korn

*Publisher:* Robert M. Tod
*Book Designer:* Mark Weinberg
*Production Coordinator:* Heather Weigel
*Senior Editor:* Edward Douglas
*Project Editor:* Cynthia Sternau
*Assistant Editor:* Shawna Kimber
*Desktop Associate:* Michael Walther
*Typesetting:* Command-O, NYC

# CONTENTS

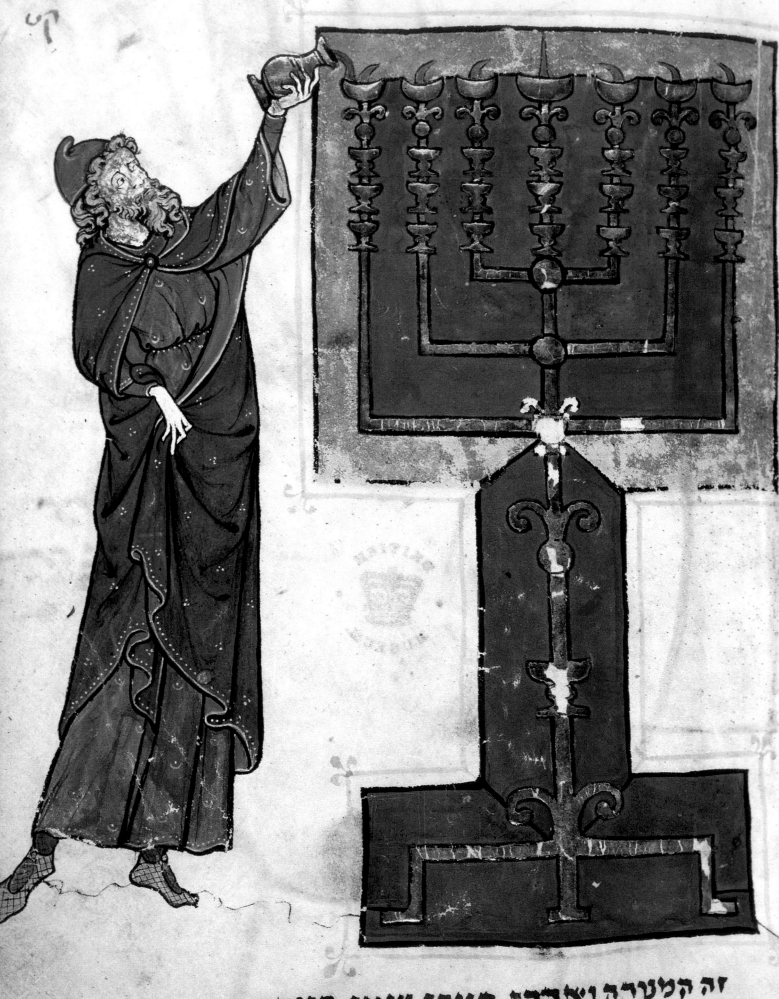

זה המטרה ואהרן חטת שמן בנירות ׀׀

# A BRIEF HISTORY OF JEWISH ART

The story of Jewish art—like the story of the Jewish religion, people, and practices—encompasses many places and many times. It is impossible to explore the world of Jewish art without an understanding of the vast world of the Jewish people themselves.

Since the Diaspora, Jewish people have almost always lived within the civilizations of others, sometimes as fully integrated members of those societies, at other times separated into their own isolated communities.

One of the aspects of Judaism that has allowed it to continue to thrive through centuries of oppression and dispersion is the ability of the religion and people to adapt and change. A blend of biblical laws, Talmudic instructions, and the changing viewpoints of rabbinic authorities, Judaism has always incorporated influences from the societies in which Jewish people live.

The pre-Christian Jews of Palestine practiced their religion very differently from medieval Jewish communities, whose customs differ from those of current Reform Jews. The Sephardic Jews of Spain and Portugal developed traditions dissimilar from those of their Ashkenazic contemporaries in Eastern Europe. Yet all are Jews.

And Jews bring those same diverse cultural influences to their art. The enforced migrations of Jews have produced a stunning variety of artforms that are all Jewish, although those same wanderings and persecutions have resulted in the irretrievable loss of many pieces through the centuries.

A large part of the remaining Jewish art is in the form of ceremonial objects and decoration. Jewish law, custom, and tradition to some extent dictate every aspect of the life of a Jew: the rituals of daily life, milestones, and holiday celebrations. These rituals are aided by items that are both functional and ornamental.

Another reason for the prevalence of ceremonial art over art for purely aesthetic purposes comes from the Bible. Jews throughout the centuries have grappled with the meaning of the Second Commandment: "Thou shalt not make unto thee any graven image, or any likeness of any thing that is in heaven above, or that is in the earth beneath, or that is in the water under the earth . . ." (Exodus 20:4) Should this commandment be understood literally to mean that Jews not make art in any form?

Opinions have varied through the centuries, particularly as there appear to be contradictions within the Bible itself. In Exodus, the Lord gives

## Moses and the Burning Bush

*Moshe Hayyim ben Menashe Mordechai, 1888 (United States); brown ink on paper; 32 1/2 x 22 1/4 in. (83 x 57 cm). Jewish Theological Seminary of America, New York.* Micrography, the only uniquely Jewish art form, uses miniature writing to shape images. The image of Moses approaching the burning bush, as well as the background and border, is entirely made up of minute Hebrew and English letters, including excerpts from the Bible.

## Aaron Kindles the Menorah

*1278, from French Hebrew Bible; British Museum, London.* The seven-branched *menorah* has figured prominently in Jewish art through the ages. This page is unusual for its time period in that a human figure pouring oil has been added to the traditional symbol.

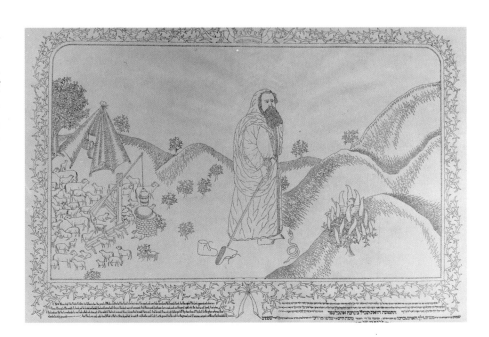

### Synagogue Mural

*245 C.E., Dura Europos Synagogue, Syria; fresco. The Jewish Museum, New York.* The 1932 discovery of the remains of murals in the Dura Europos Synagogue in what was Mesopotamia led to a whole new understanding of ancient Jewish art, ending the theory that no human forms were to be found in Jewish works of that time. The murals include biblical and historical scenes, as well as ancient Jewish symbols such as the *menorah*.

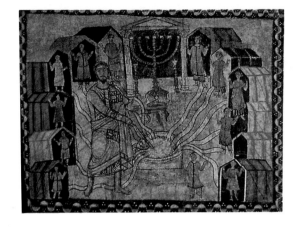

Moses specific instructions about the sanctuary that should be built: "And thou shalt make two cherubs of gold, of beaten work shalt thou make them, in the two ends of the mercy seat." (Exodus 25:18)

Later the Lord says to Moses: "I have singled out Bezalel . . . I have endowed him with a divine spirit of skill, ability, and knowledge in every kind of craft: to make designs for work in gold, silver, and copper, to cut stones for setting, and to carve wood—to work in every kind of craft." (Exodus 31:2–5)

In Ezekiel's vision of a restored Temple, wood panels were to be decorated with: "cherubs and palm trees . . . . Each cherub had two faces, a human face turned toward the palm tree on one side and a lion's face turned toward the palm tree on the other side." (Ezekiel 41:18–19)

Until this century, it was widely believed that Jews did not portray human figures until the middle ages. However, the discovery in the 1930s of painted murals at the third-century synagogue of Dura Europos in Syria dispelled that notion and led to a reassessment of the concept of Jewish art. These well-preserved murals display numerous scenes from the Bible, complete with human figures. There is even a representation of the hand of God, which might have been the basis for the later tradition among Sephardic Jews of the use of a hand for protection.

Murals and mosaics that have been found in other synagogues in and near Palestine confirm that the figures at Dura Europos were not an isolated incident. Some scholars speculate that this early Jewish art strongly influenced Christian art. These ancient floors and walls also portrayed symbols that are still commonly associated with Judaism, such as the *menorah*, the *lulav* (willow branch) and *etrog* (citron) used on the holiday of *Sukkot*, the lions of Judah, and the *shofar* (ram's

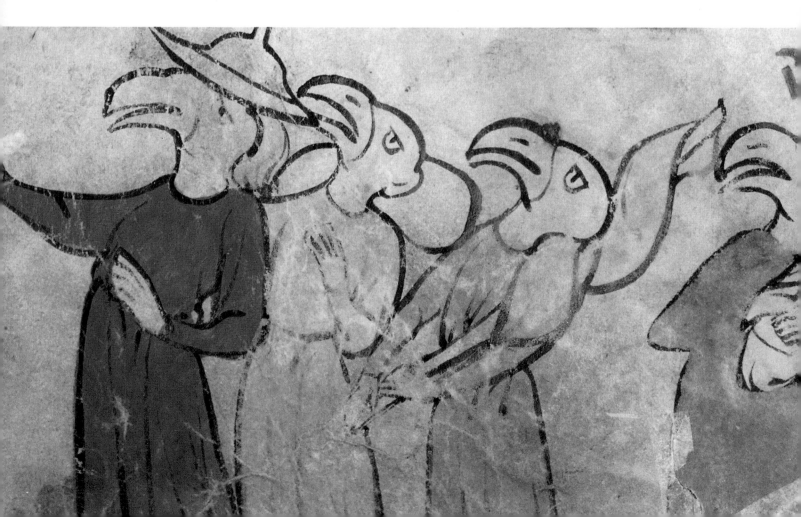

horn) musical instrument. Such symbols also appear on ancient coins, glasses, and oil lamps.

Jews of the time may have justified art that included human figures by reading the Second Commandment in conjunction with the line that follows it: "Thou shalt not bow thyself down to them nor serve them . . ." (Exodus 20:5) Together, the implication is that graven images for the sake of idolatrous worship is forbidden, rather than all graven images.

In any case, by the middle ages, Jewish illustrated illuminated manuscripts were common, including the Bible, *haggadot* (texts that accompany the Passover *seder*), Scrolls of Esther, and *ketubot* (marriage contracts). In some cases, Jewish artists used human figures but did not portray their actual faces, instead showing them from the back or covered by crowns or veils. In German manuscripts, the heads of humans were often replaced with the heads of animals, especially birds.

Interestingly, Jews who lived in Islamic countries continued the practice of eschewing human figures in art much longer than most others, largely because of the iconoclasm of the Moslem religion. Instead, they limited their illustrations of manuscripts and ceremonial objects to more abstract designs, particularly vines and flowers.

Most remaining ceremonial art dates from the past few centuries. Almost all of it includes representations of common Jewish symbols as well as biblical scenes, quotations, and depictions of holidays and everyday rituals.

The last form of art to accept the depiction of humans was that of three-dimensional images, such as busts, statues, and sculpture, which do not appear with any regularity until the seventeenth and eighteenth centuries.

Jewish artists continue to adapt the styles of many cultures and trends to create their own unique art. Early in this century, for example, there was a great surge in the works of Jewish artists as Eastern European Jews were finally able to leave the ghettoes and come in contact with developing art theories. While the art they created mirrors the trends in the art world at large, it was often distinctly Jewish in terms of background and choice of subject matter.

By its very nature, then, a survey of Jewish art is a survey of the world's art as seen through Jewish eyes. Jewish art through the centuries affords a look into the cultures and trends of various times, as well as insight into uniquely Jewish concerns, rituals, celebrations, and priorities.

**Birds' Head Haggadah**
*c. 1300, Upper Rhine, Germany; vellum; 47 leaves; 10 1/5 x 7 1/4 in. (27 x 18.5 cm). Israel Museum, Jerusalem.*
In this earliest remaining German *haggadah*, human bodies are topped with the heads of birds to avoid an accurate depiction of human figures. The birds wear the conical hats compulsory for Jewish men of the time.

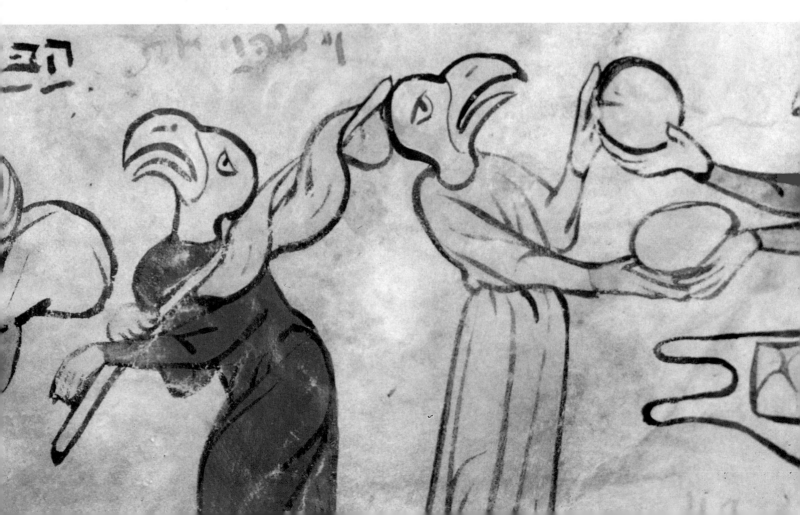

## CHAPTER ONE

# LAWS, CUSTOMS, AND TRADITIONS

Every day in the life of an observant Jew is filled with practices related to the religion—some of Biblical origin, some simply custom. These rituals evolved in part to affirm the individual's commitment to their religion, and in part to enhance the connection both with other Jews and with the divine. Centuries of interpretation, debate, and discussion have led to guidelines and prohibitions concerning everything from the way one dresses to the very food that is eaten. The home, as well as the synagogue, is

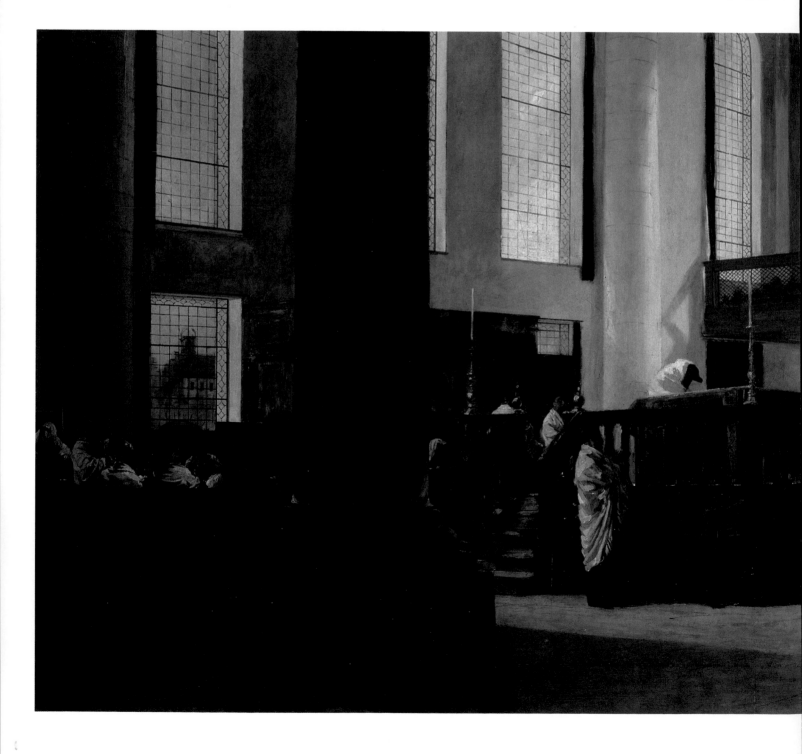

filled with items of religious importance, often colored by outside local influences.

## The Synagogue

For a Jewish person, worship takes many forms, revolving around both the home and the synagogue. Originally, Jewish worship was centered around the Temple, including sacrifices. After the first destruction of the Temple in 586 B.C.E., special places were established for prayer until the Temple was rebuilt about seventy years later. Through the centuries, synagogues evolved to be sites of assembly and study, in addition to prayer.

One of their main functions is to house the scrolls of the Torah, the most sacred of all objects in a synagogue. Today, the scrolls are kept in a permanent ark, usually in or against the wall that faces Jerusalem. Some arks are built into the walls of the synagogue, while others are freestanding, a remnant from the days when a moveable receptacle that housed

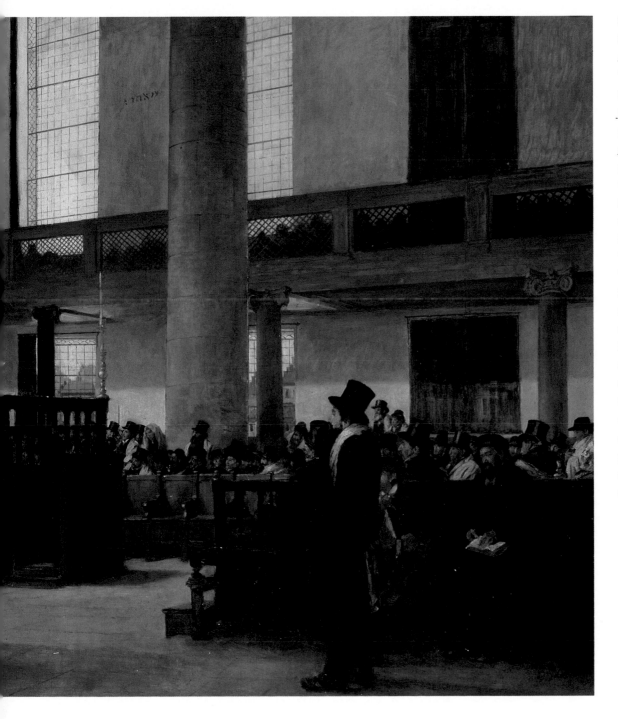

**Silent Prayer, Synagogue of Amsterdam, "The Amida" ("La Gmauida")**
*Jacques-Emiles-Eduard Brandon (1831–1897), 1897; oil on panel; 34 1/2 x 68 1/2 in. (87.7 x 174 cm).*
Gift of Brigadier General Morris C. Troper in memory of his wife, Ethel G. Troper and his son Murray H. Troper, The Jewish Museum, New York. The silent prayer (*Amida* in Hebrew) is part of three traditional daily and holiday services. One of Brandon's last works, *Silent Prayer* was composed from numerous studies made on site at the Portuguese Synagogue of Amsterdam and is the culmination of thirty-one years of concentrated study on subjects of contemporary Jewish life.

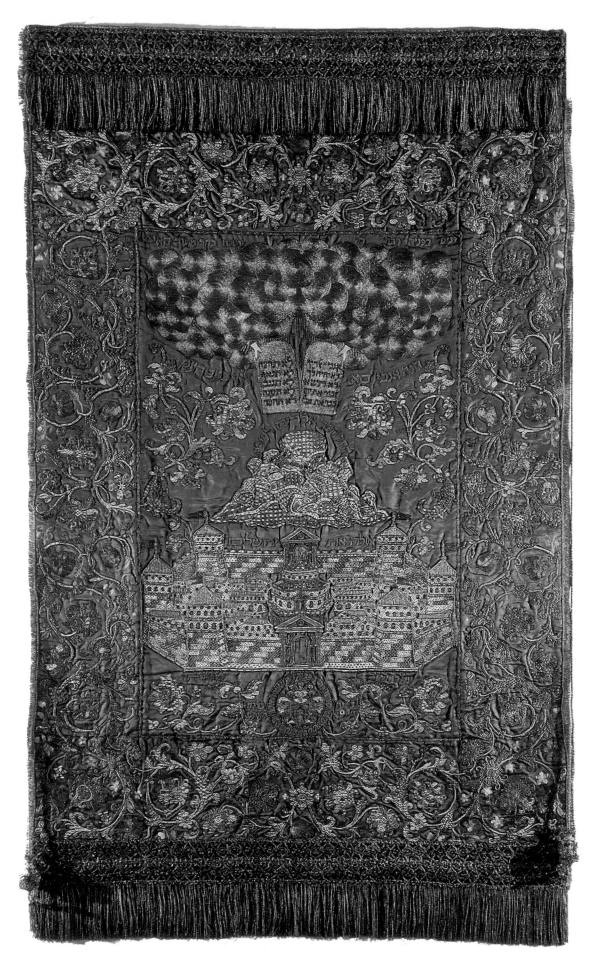

**Torah Ark Curtain**
*Simhah, wife of Menahem Levi Meshullami, 1680–1681; Venice; silk embroidered with silk and metallic threads, metallic fringe; 85 1/16 x 55 1/8 in. (216.1 x 140.1 cm). Gift of Professor Neppi Modona, Florence, through Dr. Harry G. Friedman, The Jewish Museum, New York.*
Embroidered Torah ark curtains, as well as other embroidered Torah ornamentation, were frequently made and donated by Jewish women rather than men. The flowering vines and tablets of the Law were common Jewish motifs; the depiction of Jerusalem is unusual for a Torah ark curtain, but was often used to decorate a *ketuba* (marriage contract).

the scrolls would be brought into the place of worship and then removed when the service ended.

As the most significant architectural feature of the synagogue, Torah arks are elaborately decorated, as prescribed in the Code of Jewish Law. Made of wood, brass, or silver, and often gilded, the most ornate Torah arks were made in Italy during the Renaissance. In Eastern Europe, artists took a different direction, and the arks were painted in colorful folkloric styles.

A Torah ark curtain hangs either in front of the ark or just inside the doors of the ark. Usually donated by individuals or groups to the synagogue, curtains are made of silk, velvet, linen, or wool, and richly embroidered with silk and metallic threads, sometimes appliquéd with metallic thread or lace. In addition to featuring traditional Jewish motifs, such as the *menorah*, tablets of Moses, crowns, and hands, many of the curtains are signed and dated by the embroiderer, providing a valuable historic record. The Torah itself is decorated with ornate finials, shields, crowns, binders, and mantles.

Other features of ancient synagogues were modeled on those of the original Temple and remain in one form or another today. In the center of the Temple was a raised platform from which the Priest offered his daily benediction and which was used for sacrifices. Synagogues adopted the idea, placing an elevated platform, called a *bimah*, in the center for leaders to conduct the service. Later in Reform and some Conservative synagogues, the *bimah* was moved to the front, rather than the center.

Another holdover from the days of the Temple is a special section for women, separate from where the men sit. In later synagogues, this section was either in a raised gallery or a distinct section on the same floor separated by a curtain. Only Orthodox synagogues continue this practice today.

## School and Study

One of the reasons that Judaism has survived so long may well be that practitioners are encouraged not only to learn about the religion, but to question and discuss it. All aspects of Jewish life return to the Torah—the five books of Moses—and rabbinic interpretations of its text.

Long after the completion of the last book of

the Hebrew Bible, scholars debated interpretations of its words. The debates and the ensuing decisions were summed up in the *Mishnah*, a body of literature considered the final source of Jewish law, in 220 C.E. Until the end of the fifth century, scholars continued to study the *Mishnah*, adding their own interpretations and comments. These were then included, along with the *Mishnah* itself, in two different bodies of work, both called the Talmud. Today, the Babylonian Talmud is considered the more definitive work than the Jerusalem Talmud, because it is of later date.

As Jews continued to move further from Palestine and be influenced by the local customs of the areas they settled in, discussions continued. By the twelfth century, there were enough diverging viewpoints on important questions that concerned rabbis and scholars again attempted to devise a uniform system of belief. Success eluded them until the sixteenth century, when the Spaniard Joseph Caro wrote the "Code of Jewish Law," which to this day is considered the authority.

Despite this definitive source, local customs continued to influence Jews all over the world. These differences are particularly evident when

### Mizrach

*Joel Feuersdorf, 1799; watercolor, gouache, and ink on paper; 13 1/2 x 14 3/4 in. (34.3 x 37.5 cm). Gift of Dr. Harry G. Friedman, The Jewish Museum, New York.* A *mizrach* is placed on the eastern wall of many Jewish homes to indicate the direction of Jerusalem, toward which a Jew faces during prayer. The naive-style *trompe l'oeil* of this *mizrach* includes Jewish, personal, and even political allusions.

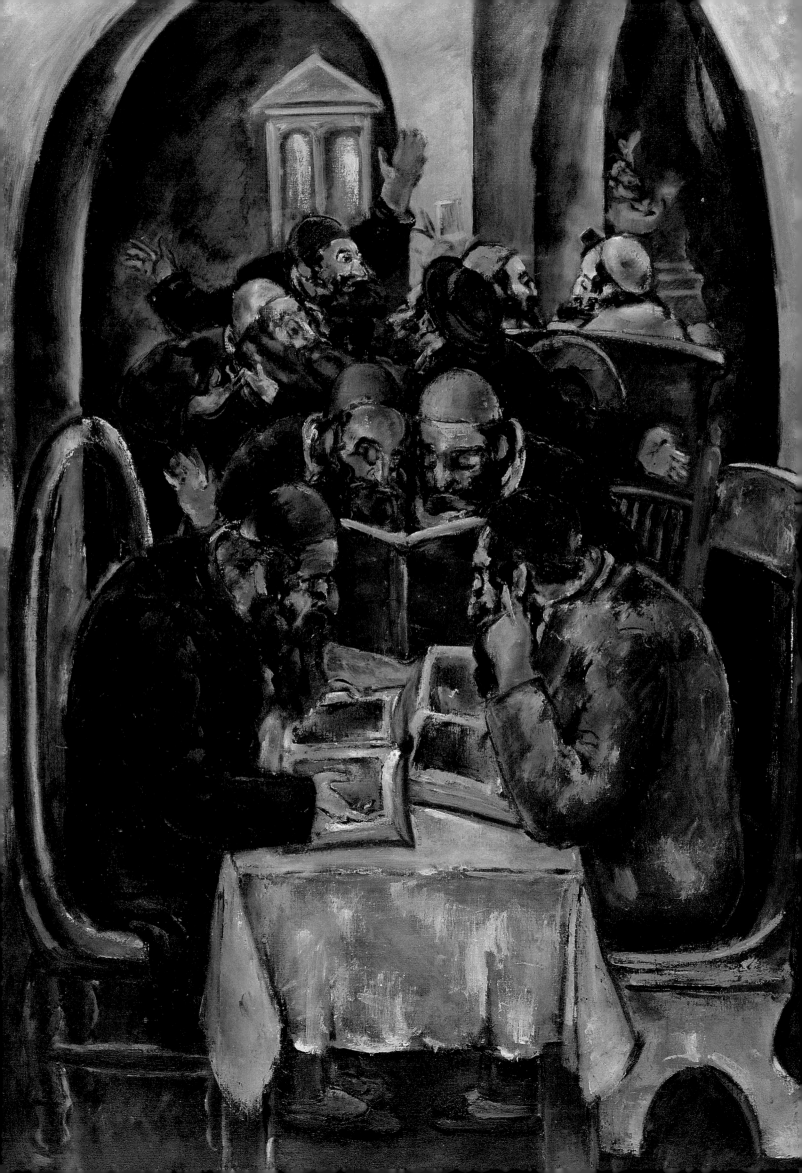

considering the traditions that emerged for the Sephardic Jews of Spain and Portugal as opposed to those adopted by the Eastern European Ashkenazic Jews. The advent of the Reform and Conservative movements also greatly changed the way some Jews viewed the religion and its observances, as did the formation of the State of Israel.

Scholars still debate the meaning of texts and their applicability to daily life. But it is not only the scholars who question and discuss such matters. Children today receive instruction both from the family and from schools. In the past, formal Jewish education was reserved only for boys, as it was believed maintaining the home was the primary function for girls and women. For most Jews today, this is no longer true, and girls are free to pursue their educational interests.

Education for a Jewish child might start as early as a Jewish daycare center and pre-school, while Hebrew school, as an addition to secular school, typically starts around the age of five or six, for a few afternoons a week. Some children attend *yeshiva*, a Jewish school that combines secular and religious education, rather than public school.

Formal education often ends either at the *bar* or *bat mitzvah*, or confirmation, although higher education is available through a number of synagogues, schools, and "Ys" offering continuing education classes for interested adults. One of the functions of the synagogue itself, in addition to being a house of prayer and assembly, is to be a house of study, or *Beth Midrash*, and especially in ultra-Orthodox synagogues, it is not unusual to find groups of men in study, contemplation, and discussion.

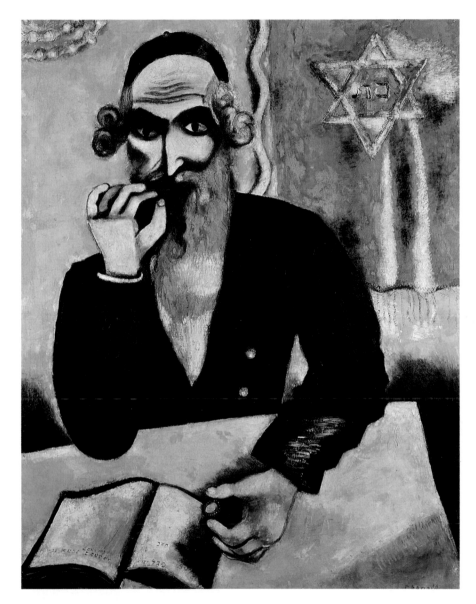

### The Talmudists

*Max Weber (1881–1961), 1934; oil on canvas; 50 x 33 1/4 in. (127 x 85.7 cm). The Jewish Museum, New York.* Weber, well-known as an American modernist, did not turn to Jewish subjects until his father's death in 1918. In dark earth tones, he portrays members of the mystical Hasidic sect at serious study in New York. Some read and contemplate alone, while others show the rapt expressions and passionate gestures of the intense discussion that traditionally accompanies such study.

### The Rabbi

*Marc Chagall (1887–1985); oil on canvas. Kunstmuseum, Basel.* Reminiscent of Rembrandt's *An Old Jew at his Study Table*, this painting depicts a rabbi in serious study of the Bible or Talmud. Except for the title of the work, there is nothing here to distinguish this man as a rabbi, as opposed to any other pious Jewish man.

## The Sabbath

A central tenant of Jewish life, the Sabbath (*Shabbat*), commencing at sundown on Friday and continuing until sundown on Saturday, is more than just a day of rest—it is a day of spiritual rejuvenation and joy. First mentioned in Genesis as the day God rested after creating the world in six days, the seventh day of the week becomes a day of rest for humans in Exodus (31:16–17): "Wherefore the children of Israel shall keep the sabbath, to observe the sabbath throughout their generations, for a perpetual covenant. It is a sign between me and the children of Israel for ever . . . ."

The traditional Sabbath begins with the woman of the house lighting the Sabbath candles and then reciting the blessing over the candles to formally usher in the Sabbath. The most common practice today is to light at least two candles, which symbolize the biblical commandment to both "keep" and "remember" the Sabbath. Some families light the candles of a seven-branched *menorah*, or candelabrum, to represent the six workdays of the week clustered around the holy day of the Sabbath, while others choose to light a candle for every member of the household. In most cases, the candlesticks are of silver or brass, sometimes inscribed with Jewish symbols. Older traditions include oil lamps and hanging Sabbath lamps, which became popular in the eighteenth century.

After the candles are lit, the man of the house recites the *Kiddush* ("sanctification"), a prayer over the Sabbath wine, before eating the Sabbath meal. Food plays an important role in the Sabbath, with three meals traditionally eaten during its course: Friday night, Saturday at around noon after morning services, and late in the afternoon following afternoon services. Common Sabbath foods include *challah*, bread made in a variety of shapes and sizes; fish, especially *gefilte* fish and herring; and *cholent*, a kind of stew that varies depending on the country of origin but typically contains meat, beans, potatoes, and other local vegetables.

In addition to festive meals, prayer and study of the Torah are important. For observant Jews, all work is prohibited on the Sabbath, although the definition of work as it has evolved over time is not always clear. Since the making of fire on the Sabbath is prohibited in the Bible, the most observant of Jews won't use electricity on the Sabbath, considering it a form of a fire. Driving a car is another example where opinions diverge: some will not drive under

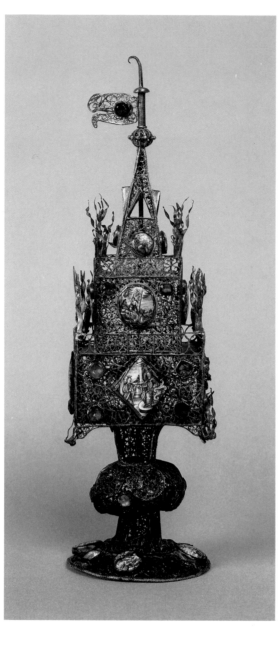

### Sabbath Spice Container

*18th century, Italy; silver filigree, colored stones, enamel medallions. Musée de Cluny, Paris.* Usually made of silver, spice boxes are used for the *Havdalah* ritual that separates the end of the Sabbath from the rest of the week. A distinctly Jewish ceremonial object, spice boxes have captured the imaginations of artisans through the centuries and come in all shapes and designs, ranging from Gothic towers to houses, animals, and flowers.

### Cup and Decanter for Kiddush Wine

*19th century, Holland; cut-glass. Joods Historisch Museum, Amsterdam.* Used on the Sabbath and holidays, this special decanter for *Kiddush* wine is inscribed with the Hebrew names of all the months, followed by the names of the holidays.

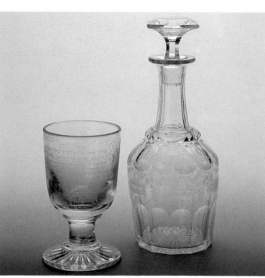

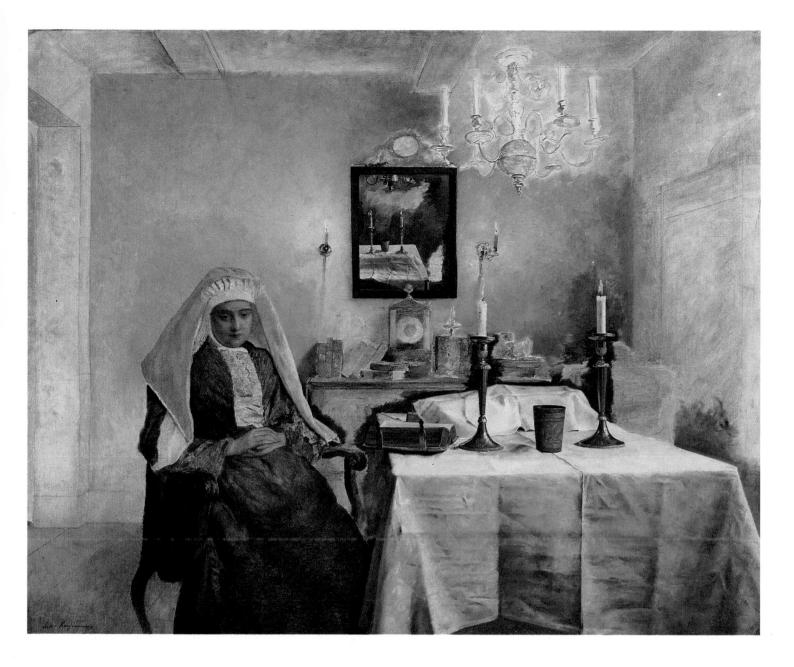

any circumstances; some find it acceptable to drive to synagogue; others will use a car for social purposes but not work-related reasons.

Because of the importance of the Sabbath, observant homes through the centuries contained many items designed solely for use on the Sabbath and holidays. Items commonly found include a white tablecloth used to cover the Sabbath table to symbolize purity, a special Sabbath lamp, a cover for the *challah*, and a decanter for the *Kiddush* wine. Cooking is not permitted on the Sabbath, so in the past special stoves were designed to keep foods warm for the twenty-four hours of the Sabbath; today one or more stove burners can be kept at a moderate temperature with a tin or aluminum sheet placed over it to distribute the heat to a larger area.

The end of the Sabbath is marked by the *Havdalah* ritual, a blessing over wine, candles, and spices, which takes place Saturday after nightfall to distinguish the Sabbath from the workweek. The special *Havdalah* cup is filled to overflowing with wine in the hope that the new week will bring an abundance of goodness. The other two items required for the blessing are the braided *Havdalah* candle, held by the youngest

### The Sabbath

*Isidor Kaufmann (1853–1921), c. 1920; oil on canvas; 28 1/2 x 35 1/2 in. (72.4 x 90.2 cm). Gift of Mr. and Mrs. M. R. Schweitzer, The Jewish Museum, New York.*

In this unfinished canvas, a lone woman sits at a typical Sabbath table, complete with white tablecloth, candles already lit, *Kiddush* cup filled with wine, covered *challah*, and the Bible. She is most likely waiting for her husband to return from synagogue, and her conservative headdress and bib indicate an Orthodox bent.

member of the family, and a spice box that holds spices which are passed around for all to sniff.

In today's society, many Jews do not observe or only partially observe the Sabbath, perhaps attending synagogue but forgoing the strict prohibitions against all "work." Even among those who don't observe the Sabbath, Friday night can be a time for gathering the family together and other forms of socializing. In the early twentieth century, Friday night lecture series and social hours became popular worldwide at synagogues and continue today.

## Clothing

In many times, periods, and places, it has been difficult to differentiate a Jewish person from any other simply by the way he or she dresses. As in other respects, Jews tend to adopt the clothing of the area in which they are living. Nevertheless, there are certain laws and customs that have remained common through the ages.

For men, one of the most important is the wearing of the *talit*, a prayer shawl with fringes (*tzitziot*) at the corners, during morning prayers. It is actually the fringes whose use are mandated in the Bible; the use of the shawl itself has only arisen out of the need for a garment to hold the fringes. All *talitot* have stripes, most often blue (once the color of the fringes) or black, although more colorful *talitot* have evolved in some cultures. They are typically made of linen, silk, or wool.

The most common form of *talit* today is the size and shape of a scarf which is draped over the shoulders. Some Orthodox and Conservative men wear larger *talitot*, more like blankets, that cover the entire body. At the top of the *talit* is an *atara* ("diadem"), a band whose purpose is to differentiate the top from the bottom, so the wearer does not inadvertently put it on upside down. The blessing recited over the *talit* is often inscribed on the band, and some are quite ornate, made of silver or metallic embroidery.

### Talit

*20th century, Yemen; woven cloth; 107 1/4 x 39 in.*
*(275 x 100 cm). Israel Museum, Jerusalem.*
The most common type of *talit* ("prayer shawl")
today is a simple blue and white stripe pattern.
However, both new and old ones show local
influences, such as this folk pattern from Yemen.

It is most common for a boy to start wearing a *talit* at his *bar mitzvah*, from which point he continues to wear it at morning services, although in some communities, men do not wear a *talit* for morning services until they marry. Another form of *talit*, worn only by the Orthodox today, is the *talit katan* or "small" *talit*, designed to be worn under the clothes all day long. Boys can start wearing these at around the age of three.

The other important ritual object for morning prayers for men is *tefilin*: leather cubes, also called phylacteries, which enclose parchment strips containing passages from the Torah. *Tefilin* are worn on the left arm and on the forehead, affixed with leather straps. The strap of the arm cube is wound around the left arm seven times to hold the *tefilin* in place, while the strap of the head cube hangs loosely. The use of *tefilin* also dates from the Bible; in Deuteronomy (6:8 and 11:18), Jews were

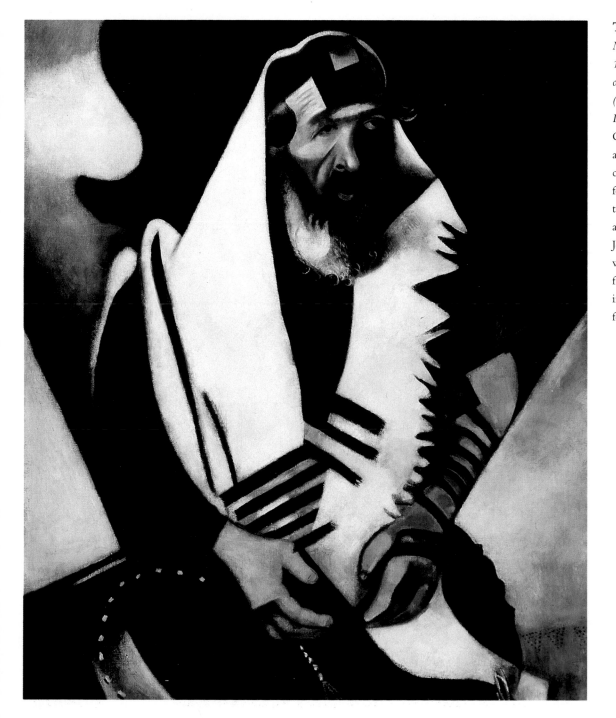

**The Praying Jew**
*Marc Chagall (1887–1985), 1924 copy of a 1914 work; oil on canvas; 46 x 35 in. (116.9 x 88.9 cm). The Art Institute of Chicago, Chicago.* One of the foremost Jewish artists of the twentieth century, Chagall is known for applying modern painting techniques to ancient themes and scenes from typical Jewish life. This Jewish man wears the traditional attire for morning prayers, including *tefilin* upon his forehead and arm and a *talit*.

instructed to "bind them as a sign upon your hand and as a symbol on your foreheads."

The use of *tefilin* or a *talit* by women was traditionally frowned upon, although today some women choose to wear them, but it is not common.

Another practice for men is covering their heads with a skullcap called a *yarmulke* in Yiddish and a *kipa* in Hebrew. The practice of covering the head, while not biblical, does date to the Talmud. Its acceptance has varied through the ages, considered custom but not law in some societies and shunned in others. Even in cultures where covering the head was considered law, men sometimes wore whatever head fashion was in vogue, rather than the skullcap. In some countries, Jews were required by law to wear special hats to differentiate themselves from Christians. Today, Orthodox Jews wear the skullcap at all times; most

Conservative Jews wear it only during prayer; and Reform congregations typically leave it up to the individual whether or not to cover the head during prayer.

On the other hand, the practice for a woman of covering her hair is of biblical origin, and was adhered to in ancient times as a sign of modesty. Women most often wore scarves and veils to cover their hair, although, as with men, the exact form of the hair covering varied depending on the customs of where they lived. Today only ultra-Orthodox women wear headcoverings at all times; some continue a practice of shaving their heads, although the shaven head is covered by either a scarf or wig. Ultra-Orthodox women also wear long sleeves and skirts to cover their bodies as fully as possible. Most Orthodox and some Conservative women cover their heads in synagogue, while Reform women typically do not.

**Woman's Cap**
*1845–50, Frankfurt; net and lace; 8 1/4 x 22 7/8 inches (21 x 58.1 cm). Gift of Mrs. Martha Nitrini, The Jewish Museum, New York.*
Married Jewish women are forbidden by Jewish law to be seen by anyone but their husbands without a headcovering. Jewish women typically adopted styles of headcovering in keeping with their society. Only the ultra-Orthodox continue to adhere to this law.

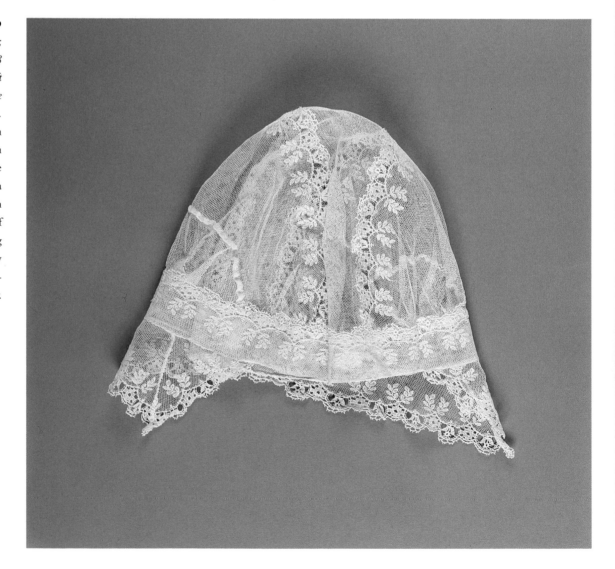

## The Mezuzah and Amulets

Religious or not, most Jewish people place a *mezuzah* on the doorpost to their home. More observant Jews also place a *mezuzah* on the doorpost of each room in the house in which people "live," such as a bedroom, living room, kitchen, and so on. In actuality, the word *mezuzah* means "doorpost," but through common usage, it also means the small case attached to the doorpost that contains a rolled-up parchment inscribed with verses from the Bible.

The origin of *mezuzot* (the plural of *mezuzah*) dates to the Bible (Deuteronomy 6:9): "And thou shalt write them upon the doorposts of thy house and upon thy gates." *Mezuzot* serve both to remind Jewish people of God's laws and as a symbol of unity with other Jews.

Many Jews also regard the *mezuzah* as a kind of protection for the home and its inhabitants, a belief started in talmudic times and carried through the middle ages to the present day. Usually made of silver, brass, or wood, *mezuzot* range from the relatively simple to the ornately decorated. Since the time of the thirteen-century *Zohar*, one of the two books that constitute the Kabbala or Jewish mysticism, the word *Shaddai*, used as a synonym for "God," typically appears on the back side of the parchment, visible through a small opening on the case. In addition to the doorposts of homes, *mezuzot* are now often found on the doorposts of buildings in Israel and synagogues worldwide.

In part as a symbol of Judaism and in part as a lucky charm, some Jews also wear *mezuzah* pendants. Through the years, Jews have worn other amulets, most often of silver, to protect against misfortune, despite the fact that most rabbinical authorities disapprove of such superstitious practices. Like the *mezuzah*, amulets

### Rothschild Manuscript 24

*c. 1470, northern Italy; thin vellum; 473 leaves; 8 1/4 x 4 1/2 in. (21 x 11.6 cm). Israel Museum, Jerusalem.* The richly illuminated Rothschild Miscellany contains over fifty religious and secular books. This illustration from one of the books is a rare depiction of a doorpost amulet from that time; no Renaissance mezuzah cases survive. It is an old custom to touch the mezuzah with the fingertips, as seen here, then kiss the fingers when entering or leaving the home.

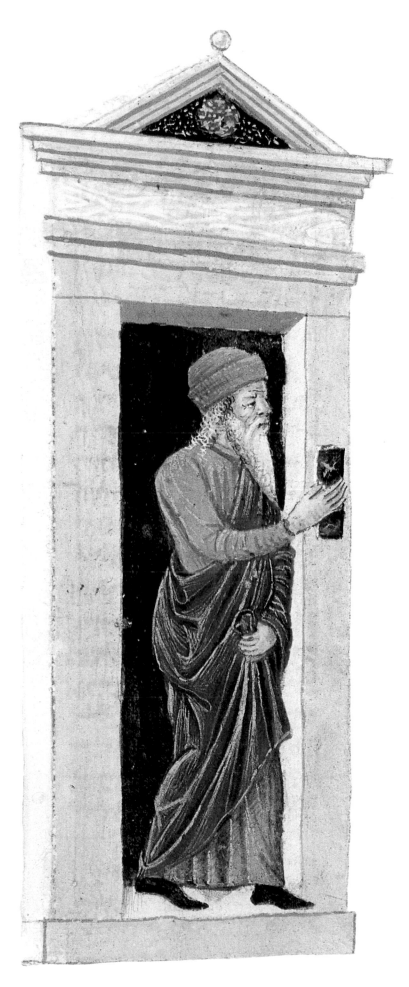

**Cofranetto**

*c. 1470, Ferrara, Italy;*
*silver, partly gilt, niello;*
*4 3/4 x 2 3/4 in.*
*(12 x 7 cm). Israel*
*Museum, Jerusalem.*
The front of this "house-wife's casket," made for holding keys and other objects of importance, is decorated with the three duties of every married Jewish woman, from left to right: baking bread for the Sabbath, ritual bathing, and kindling the Sabbath and holiday lights.

were often inscribed with the name *Shaddai* and might include "magical" texts to ward off the "evil eye."

Two currently popular necklace charms are the Hebrew word *chai*, meaning "life," and the six-pointed Star of David (*Magen David* in Hebrew). These are typically worn more as an affirmation of Judaism than for protection. Although the earliest known example of the Star of David appears in the first-century C.E. synagogue of Capernaum on the shores of the Sea of the Galilee and the star continues to appear throughout the centuries, it was not until seventeenth-century Prague that it was used as a specifically Jewish symbol. The star is often used to decorate items of ritual art or religious significance, such as Passover *seder* plates, Hanukkah lamps, and tombstones. In 1948 the star was incorporated into the new flag of Israel.

## Other Customs

With the increasing popularity of Conservative and Reform synagogues, many of the more stringent observances of Judaism fell into general disuse, although they are still observed by Orthodox Jews. Morning prayer, complete with *talit* and *tefilin* is one such practice.

Another is strict adherence to the dietary laws as laid out in the Bible. Although some people believe that the original purpose of the laws was

related to health, no such reason is stated in the Bible. In fact, the only reason given is: "For I am the Lord your God! Therefore sanctify yourselves and be holy for I am holy." (Leviticus 11:44)

In addition to a prohibition against the meats of certain animals altogether, Jewish law requires that an animal must be ritually slaughtered for it to be kosher. Further biblical injunctions prohibit the mixing of dairy and meat products at the same meal. In fact, separate dishes must be used for each. Orthodox Jews observe the dietary laws, while most Conservative and Reform Jews do not.

Two other rituals concern cleanliness. One is the washing of hands that precedes each meal (called *netilas yadayim*). The *laver*, a tall, cylindrical vessel used for handwashing, is usually made of copper or silver with twin handles extending from one side.

The second is the practice of immersing oneself in a *mikvah*, a body of natural water, for ritual cleansing. In biblical times, the *mikvah* was used to cleanse a variety of impurities; later its use was much more limited. Today, it is used mostly by ultra-Orthodox women for ritual cleansing seven days after the end of their menstrual period. Conservative and Reform women do not follow this practice. It is also sometimes still used by very Orthodox men prior to the Sabbath and holidays and by scribes before beginning work on a Torah scroll.

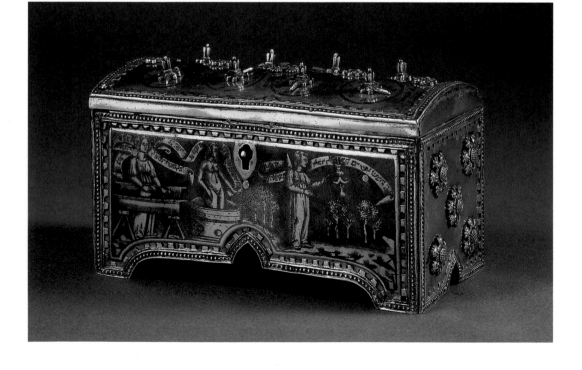

**Hamburg Miscellany**
*1427, Germany; vellum;*
*205 leaves; 11 3/4 x 8 1/2 in.*
*(30 x 22 cm). Hamburg Staats und*
*Universitaetsbibliothek, Hamburg.*
A collection of liturgy, customs, and lamentations, the Hamburg Miscellany was signed by the scribe Isaac Ben Simhah Gansmann. This page (folio 79V.) shows a Jewish woman immersing herself in a *mikvah* before joining her husband, who awaits her in bed.

הראשון בתה נתה רעי ואשר ואשה בתורה

זמזב להרוג שתת אריר זר יהיר בעברות טהריס

זבחב בכבש אלה ביהודי זמם אפתה השביעי קה

קטנב זהב אעשרד אליר בב זיגזתיר לי למשנה ה

כתוב זורדז העלב הטוב לבר

ועק הרגיבי לביה תאחר זגה

זיהתי להשתהות לאל אחר

רבודיר בושלרשע הק

חזק מזהן בלי פשעיחסן

הלד ולכבלם טיעשעזתה

הורתב משפטי בגיה המטה

נפשה על גזבה חלפה זהשב

ריבה לקזגה חבטי אבגר

לעזיר חסריב אילזיהירבתם

זפוי חנזז כרוגי בלתר וכזרי טפס עזר ביזז

מריה טיפטופי אשר לא יבריה טמירס יזזג ההיג

יקרא טיבס זכר שמי יהזרי טבזחזקשרזז כבזי גרי

סרייה זבקזחת להכביר בשליי טזבי טזלזת מיזס

מזגשהזב היזז ל נטז קיזשקיזשב מזגס

בזגשזקב להזמיל טזרזב סקית גס

יהיר זגישא שמי

שזב בז זייזז לבזלס קזזאת ביזס

**Hear, O Israel**
*David Bomberg (1890–1957), 1955;*
*oil on canvas; 36 1/4 x 28 1/4 in.*
*(92 x 71.7 cm). The Jewish Museum, New York.*
The intensity of the emotion that this shrouded man feels
for the Torah, the symbol of Jewish religion, is enhanced by
the thickly painted, intense colors of the late Expressionist
style. One of Bomberg's last paintings, it is possibly
a self-portrait of the artist, an important twentieth–
century British painter who eventually settled in Spain.

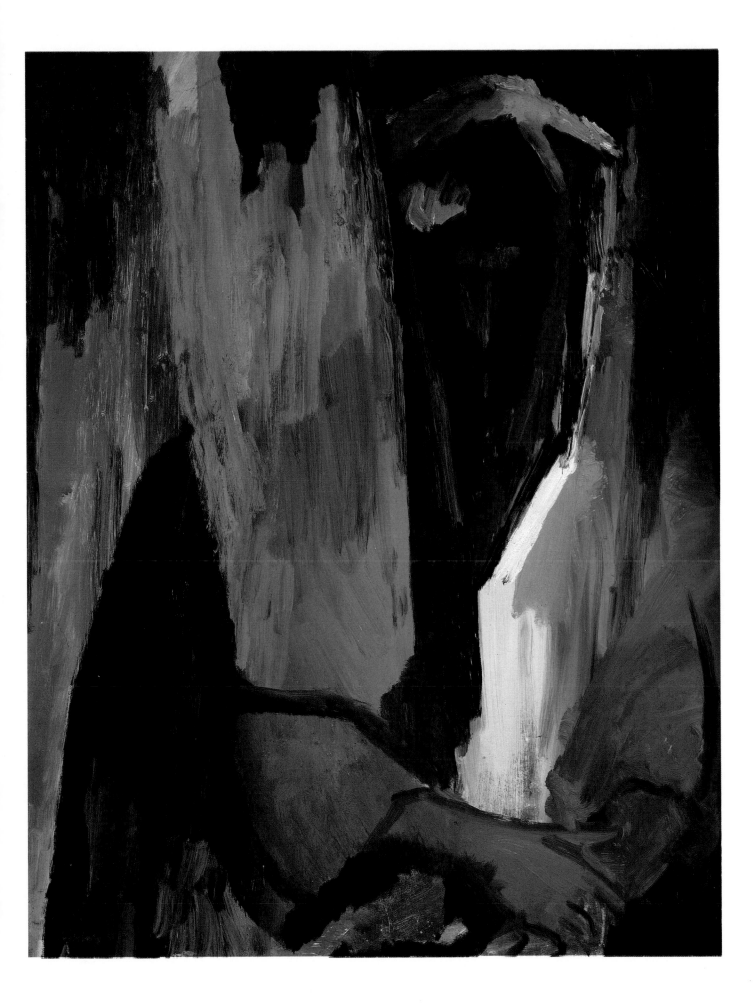

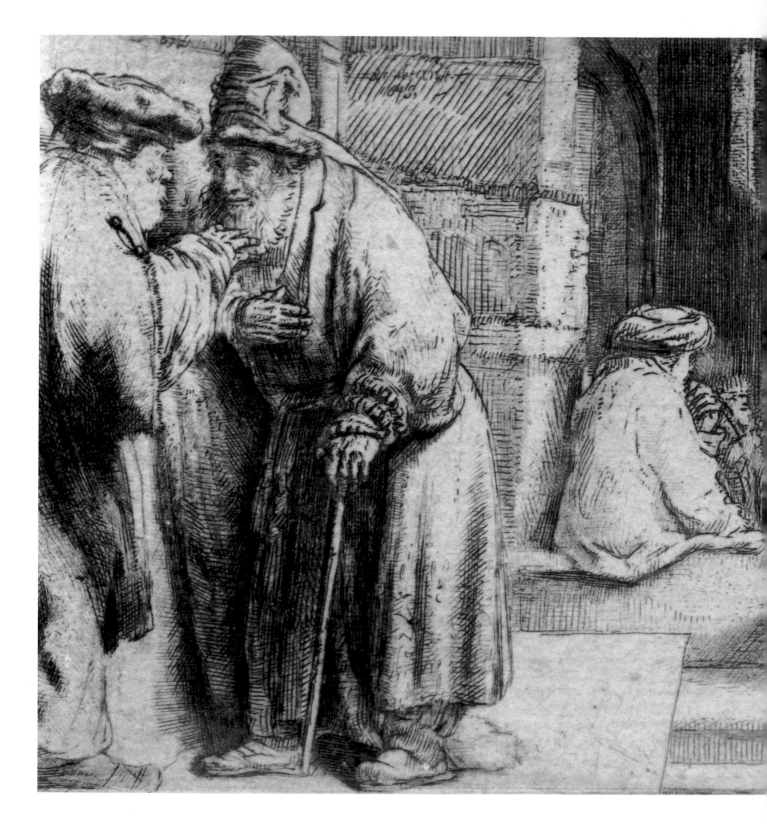

**The Synagogue**
*Rembrandt van Rijn
(1606–1669), 1648;
etching on paper; 3 x 5 1/8
in. (7.6 x 13 cm). Gift of
Dr. Harry G. Friedman, The
Jewish Museum, New York.*
Everyday Jewish life was
a favorite subject of
Rembrandt, who lived
in the Jewish quarter of
Amsterdam. This etching
provides a realistic account
of seventeenth-century
German Jews in Holland,
to which Jews of many
nations immigrated for its
religious tolerance. The ten
men portrayed in various
groupings might represent
the *minyan* (the presence
of ten men) necessary for
a Jewish religious service.

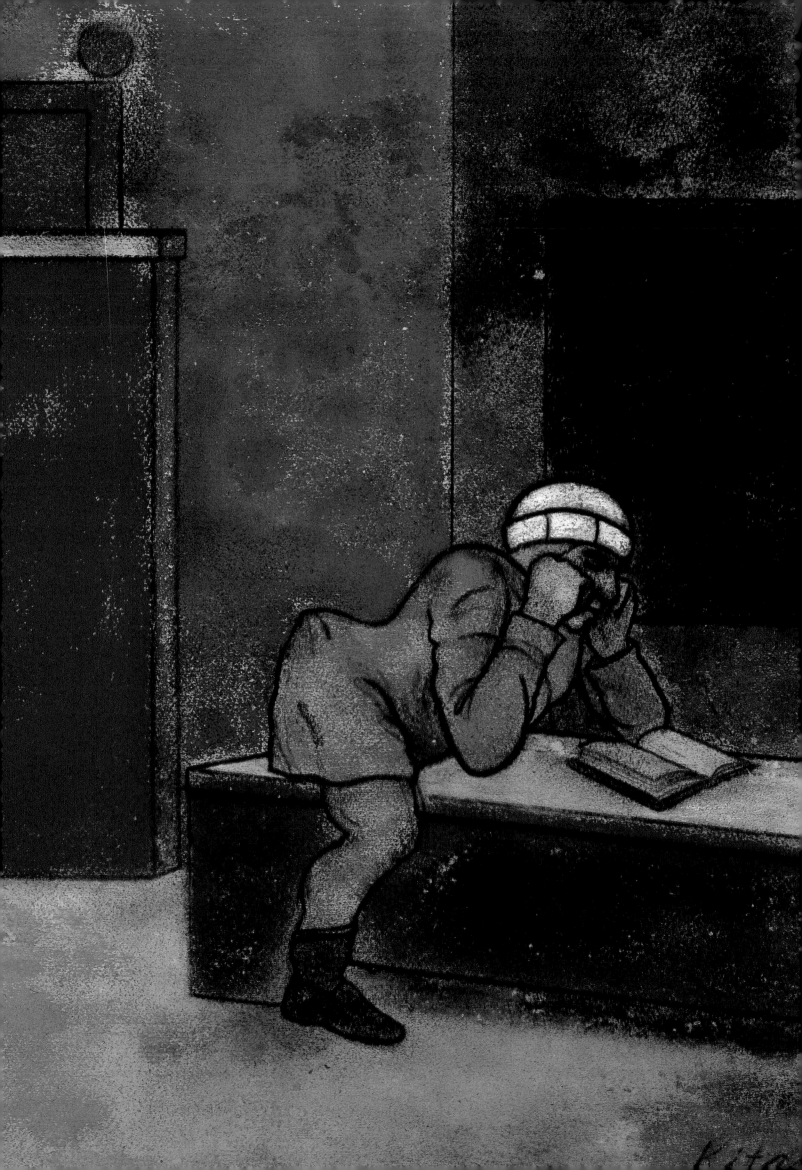

### Mezuzah

*Harley Swedler (b. 1962), 1991; bronze, cast with patina finish; sterling silver, stainless steel, and rolled glass; 4 1/2 x 2 1/4 in. (11.4 x 5.7 cm). Gift of Edna S. Beron and Harley Swedler, The Jewish Museum, New York.* The English words on this modern *mezuzah* highlight its purpose: to serve both as a reminder of God's laws and as a symbol of loyalty to other Jewish people.

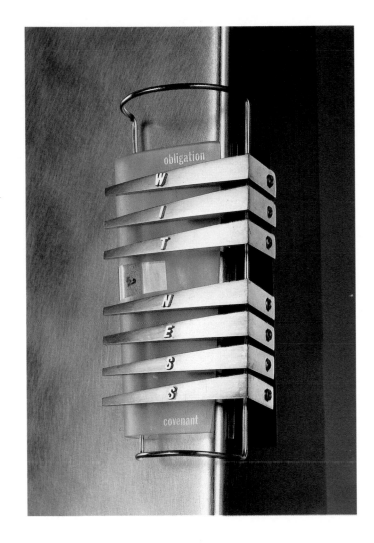

### Study for the Jewish School (Joe Singer as a Boy)

*R. B. Kitaj (b. 1932), 1980; pastel and charcoal on paper; 30 1/4 x 22 3/4 in. (77.5 x 56.6 cm). The Jewish Museum, New York.* The brightly colored simple geometric pattern of the background highlights the lone figure deep in study. Jewish study takes place in the home, in the synagogue, and at school, both as a solitary practice and in the company of others.

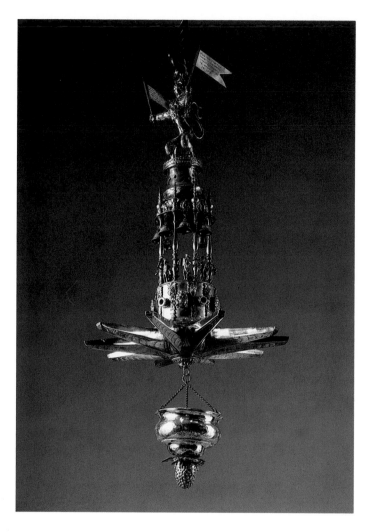

### Hanging Sabbath Lamp

*Late 18th century; Poland; cast brass. The Jewish Museum, New York.*
Hanging lamps are just one possible way of fulfilling the need
to have "beautiful light" on the Sabbath. In the middle ages, star–
shaped lamps were popular with people of all religions for regular
light. Ashkenazic Jews used them for the Sabbath long after others
stopped, eventually leading to their name *Judenstern* ("Jewish Star").
The most popular practice today is to light two or more candles.

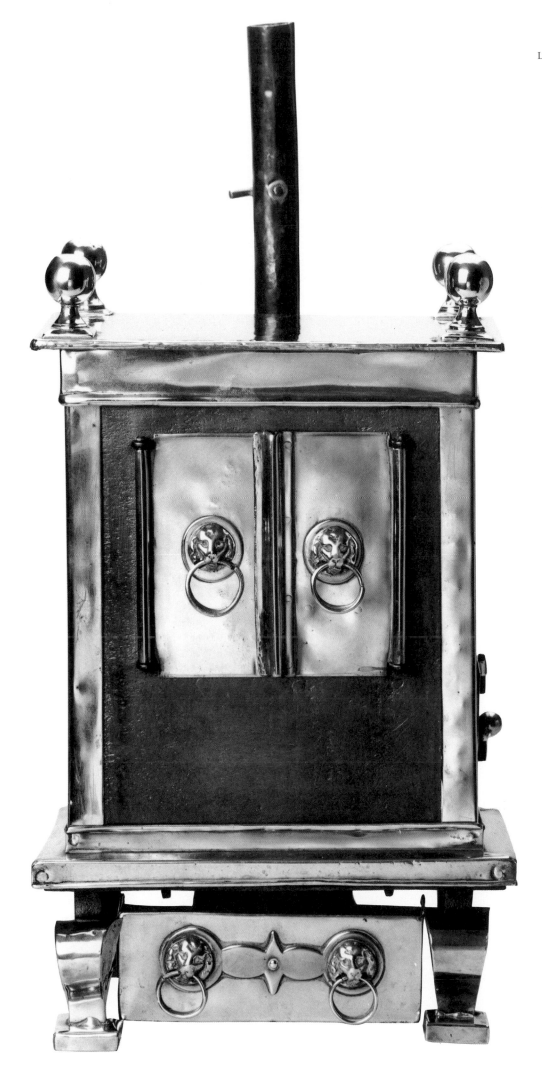

**Miniature
Sabbath Stove**

*19th century, Holland;
brass and iron;
14 x 8 1/2 x 6 in.
(35.5. x 21. 5 x 15 cm).
Joods Historisch
Museum, Amsterdam.*

The lighting of fire
is prohibited on the
Sabbath. This minia-
ture from Holland
depicts one kind of
special stove used
to keep food warm
on the Sabbath. It
might have been a
model for a real stove.

## Wall Amulet

*Late 19th century, Carpathian Mountains, Russia; paper cutout*
*decorated with watercolors, black ink lettering; 11 3/4 x 8 1/4 in.*
*(30 x 21 cm). Jüdisches Museum der Schweiz, Basel.*

Wall amulets were particularly popular for protection of both mother
and child during childbirth. In addition to psalms and biblical quotes, this
amulet lists the names of righteous biblical couples and three angels who
protect against the demon Lilith. The Star of David recurs several times.

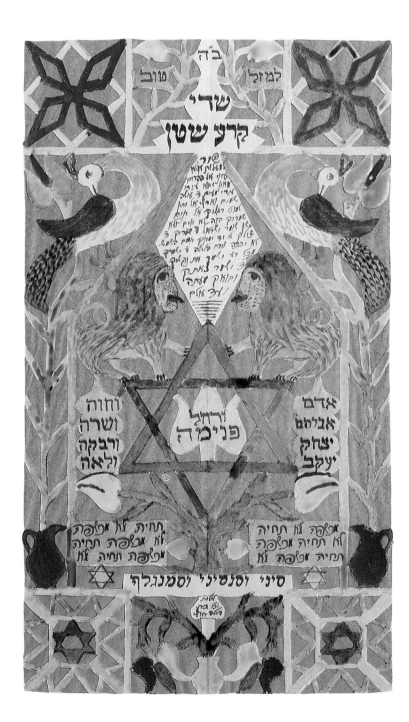

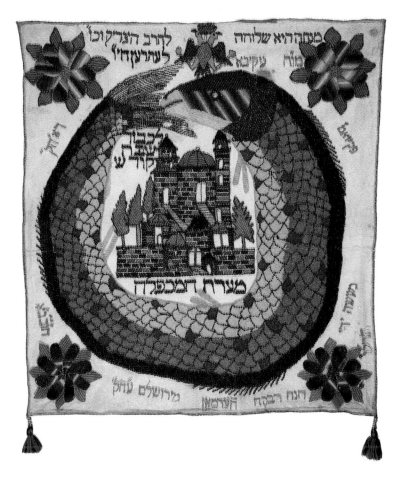

**Challah Cover**

*19th century, Poland; embroidery on velvet;*
*27 x 21 1/4 in. (69.5 x 54.5 cm). Israel Museum, Jerusalem.*

The Hebrew words "Holy Sabbath" mark the Polish decorative cloth used
to cover the *challah*. Early Talmudic scholars compared the Sabbath to
a bride; the *challah* is unveiled like a bride after the blessing. *Challah* covers
are decorated with colorful embroidery, fringe, depictions of ritual
objects and foods, and inscriptions of the Jewish benediction over bread.

## Shpanyer Band

*c. 1830, Eastern Europe; cotton, silver, and copper;*
*3 1/2 x 32 3/4 in. (9 x 83 cm). The Jewish Museum, New York.*
This band made of *shpanyer arbeit*, a method of intricate metal
thread embroidery, was most likely used as an *atara* ("diadem")
for a *talit*. Since *talitot* are square rectangles with fringe at each
side, the *atara* is necessary to know which side is the top.

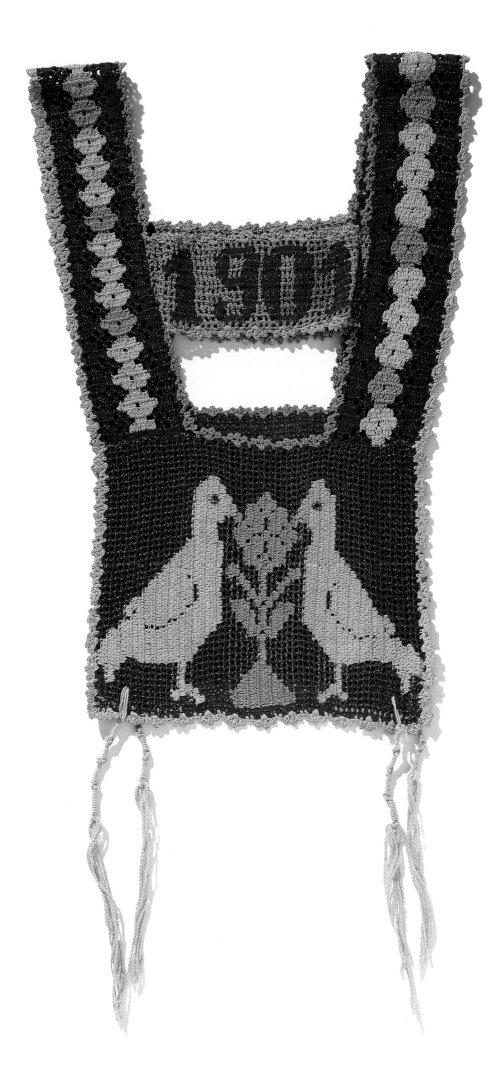

**Talit Katan**
*Anna Banks, 1901;*
*Portsmouth, England;*
*crocheted cotton; 33 3/4 x 8*
*3/4 in. (86.5 x 22.6 cm).*
*Hebrew Union College*
*Skirball Museum,*
*Los Angeles.*
In keeping with the
injunction to wear
*tzitzit* ("fringes"), ultra-
Orthodox Jewish men
wear a *talit katan* under
their clothes all day long
as a constant reminder
to observe the laws of
the *Torah.* The *talit katan*
is also called an *arba
kanfot* ("four corners").

### Book of Blessings

*Aaron of Givitsch; Vienna, 1724;*
*vellum, 17 leaves; The Library*
*of the Jewish Theological Seminary*
*of America, New York.*
This Book of Blessing provides
daily prayers and illustrations
of when they are to be recited.
Here, the woman is saying her
nightly bedtime prayer, the
*Shema*, before retiring. The *Shema*,
a passage from Deuteronomy
6:4–9 that begins with the words
*Shema Israel* ("Hear O Israel"), is
also part of every religious service.

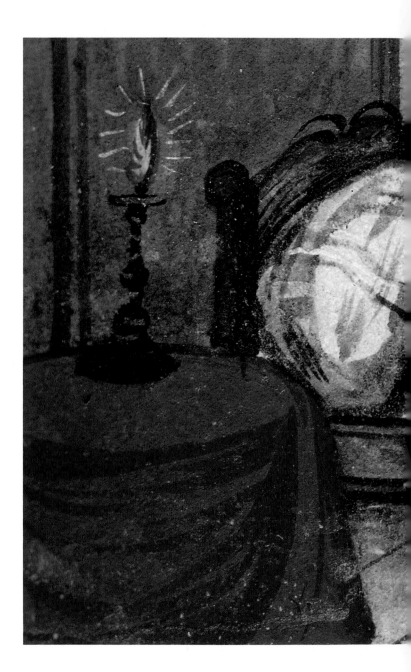

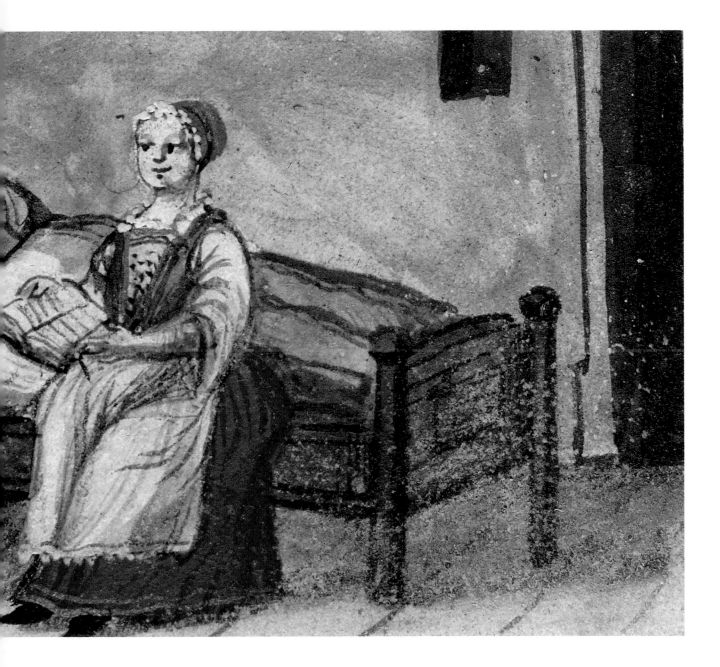

**Amulet**

*18th century, Italy; silver, partly jet; 3 5/8 x 3 1/4 in. (9.3 x 8.3 cm). Hebrew Union College, Los Angeles.*

Although their use has consistently been frowned upon by most rabbinical authorities, amulets have a long-standing tradition. They typically include "magical texts" to ward off misfortune and, like this one, are often inscribed with the word "*Shaddai*" for protection.

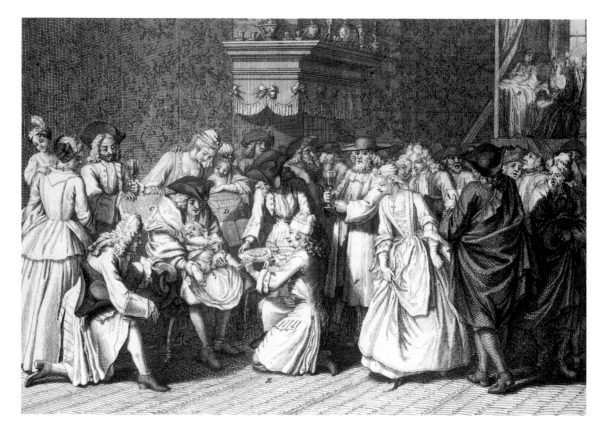

## Circumcision Ceremony

*Bernard Picart (1673–1733);*
*plate from* Cérémonies et
Coutumes Religieuses; *1726.*
*Rijksmuseum, Amsterdam.*
A French engraver, Picart
moved to Amsterdam in 1710,
where he supplied plates for
an eleven-volume work that
recorded the ceremonies of all
religions in various countries.
Here, the *sandek* (godfather)
holds the child while the *mohel*
prepares for the circumcision
as family and friends look on.

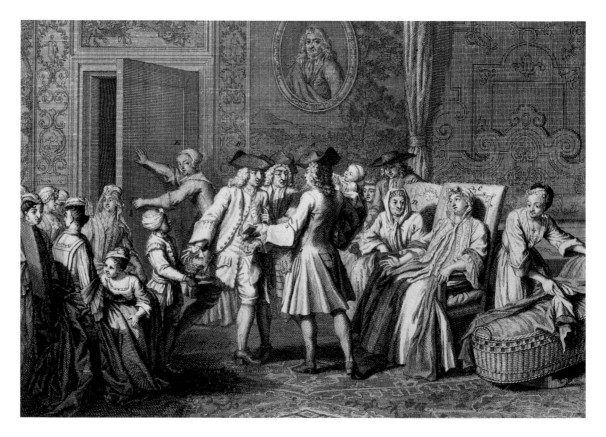

## Buying Back the First Born

*Bernard Picart (1673–1733);*
*plate from* Cérémonies et
Coutumes Religieuses; *1726.*
*Rijksmuseum, Amsterdam.*
Thirty-one days after the
birth of a woman's first male
child, the father "buys" him
back from his priestly obliga-
tion during the *Pidyon Haben*
redemption ceremony. Here,
the *Kohen* holds the child
while the father prepares to
pay him; the mother watches
from her seat at the front right.

# CHAPTER TWO

# MILESTONES

The most important milestones in the life of a Jew are those that forge and strengthen family bonds, especially marriage and birth. The *bar* or *bat mitzvah* at age thirteen, when a child is considered an adult and affirms his or her dedication to the Jewish religion, extends the sense of cohesiveness to the community at large. These joyful moments, as well as the sorrow of death, are typically shared with family and friends. Through the ages, these turning points have acquired a number of rituals and associated objects that enhance the traditions and strengthen the sense of belonging to a larger community.

## Birth

The birth of a child to a Jewish couple marks not only the continuing existence of their individual family but of the Jewish people as a whole. A number of traditions, and their corresponding art, have evolved in response to this all-important event.

Some of the rites of childbirth—such as the past use of amulets and talismans to protect the mother and child—are based on folklore, rather than the Bible or Jewish Law. Their origin, however, did not diminish their importance, and such amulets were found worldwide. Of paper or silver, these often very ornamental objects were typically inscribed with "magic" texts and the word "Shaddai," and were worn by the expectant mother or hung near the mother or the crib as protection. A simplified version of such amulets for the twentieth century is a red ribbon on or near the child's cradle.

One of the most important rites associated with birth is the *brit* (circumcision) for a male baby. Held on the eighth day after birth, the ritual circumcision reaffirms the covenant made in Genesis between God and Abraham and the Jewish people. Even today, the circumcision is performed by a *mohel*, a person whose sole job is to perform circumcisions, while the child is held by the *sandek* ("godfather").

The handles of the knife used by the *mohel* are often ornately decorated; usually made of silver, copper, ivory, or mother-of-pearl, they may feature abstract designs, representations of the scene of the *brit*, animal and floral ornamentations, and often jewels. The blade itself is sometimes decorated, as are the cases the instruments are kept in. The *mohel* might also keep an elaborately fashioned book with the names of those he has circumcised.

Until the tenth century, most circumcisions took place at home with just the *mohel* and the child's father in attendance. Later the *brit* occurred at the synagogue, surrounded by all the congregants. Many of the objects associated with the *brit* took on artistic importance, such as embroidered cushions for circumcision benches and a permanent Chair of Elijah, an empty seat reserved for the prophet, at the synagogue.

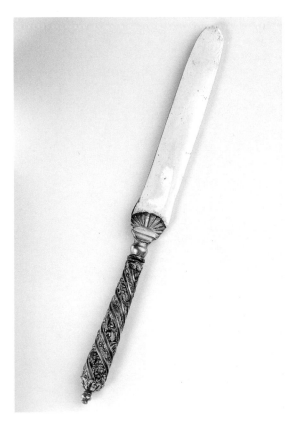

**Circumcision Knife**
*17th century, France;*
*copper, gilt, and enamel.*
*Kestner Museum, Hanover.*
The handle and sometimes the blade of the knife used by the *mohel* is often richly decorated in keeping with the importance of the ritual circumcision. Some *mohels* have matching sets of instruments, which include scissors, bowls, and vials.

Today's *brit* is just as likely to take place at the parents' home, surrounded by friends and family, as in the synagogue.

A male child is also officially named at the *brit*, while a female child was typically named in synagogue at the first Sabbath or other occasion when the Torah was read. This, too, may take place in the home nowadays.

Two other important rites take place around the time of the birth of a male child. The first is a party either on the first Friday night following the birth or the night before the *brit*. Called a *Shalom Zachar* ("welcome to the male child"), the party is of Kabbalistic origin and is basically a time when friends and family gather to celebrate the birth and socialize. Today, some couples have a similar type of party to celebrate the birth of a female child.

The other ritual occurs thirty-one days after the birth of the first male child. The child is brought to synagogue for a redemption ceremony called *Pidyon Haben*, when the father redeems his son from the priestly obligation prescribed for a mother's firstborn male child in Exodus. To do this, he pays five *shekalim* (today considered five silver dollars) to the *Kohen* or priest, who accepts the money and blesses the child. During the ceremony, the child is sometimes carried on a heavy silver platter, usually ornately decorated.

## Bar Mitzvah/Bat Mitzvah and Confirmation

One of the most important days in the life of a Jewish child is the thirteenth birthday, when a boy becomes a *bar mitzvah* ("the son of commandment"). According to Jewish Law, at this time, the child is now responsible for carrying out the *mitzvot* ("commandments") and makes the transition from child to man.

### Bar Mitzvah

*Unknown artist; color etching; 15 3/4 x 23 1/2 in. (40 x 60 cm). Judaica Collection Max Berger, Vienna.*
In preparation for his bar mitzvah, which marks the passage from child to full member of the Jewish community, this thirteen-year-old boy is being helped to place his *tefilin* (phylacteries). He will then don his *talit* ("prayer shawl") before reading from the Torah for the first time.

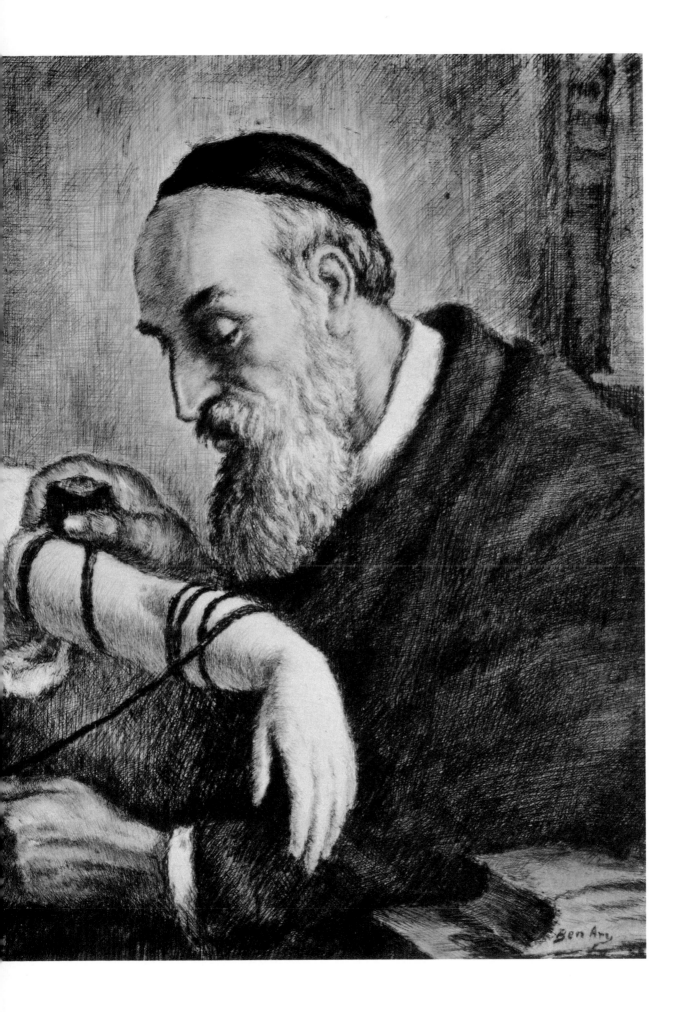

**Tefilin Bag**

*1900, Russia; velvet embroidered with silk; 7 1/4 x 6 1/4 in. (18.5 x 16 cm).*
*Gift of Dr. Harry G. Friedman, The Jewish Museum, New York.*
In addition to his *talit* or prayer shawl, the *bar mitzvah* boy
wears *tefilin* (phylacteries) for the first time. Small leather boxes
affixed to the forehead and arm, *tefilin* contain four biblical passages.
When not in use, they are often kept in silver boxes or velvet bags.

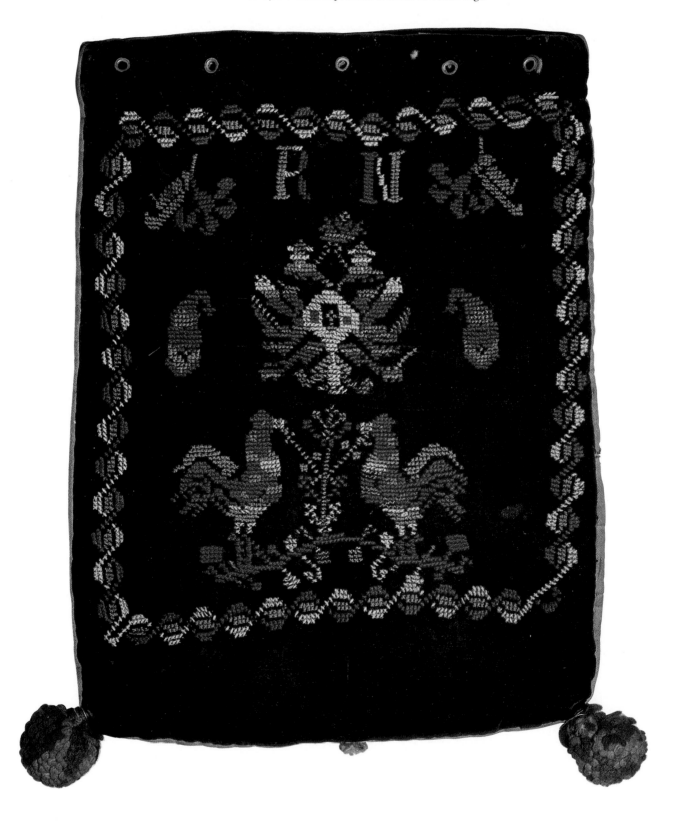

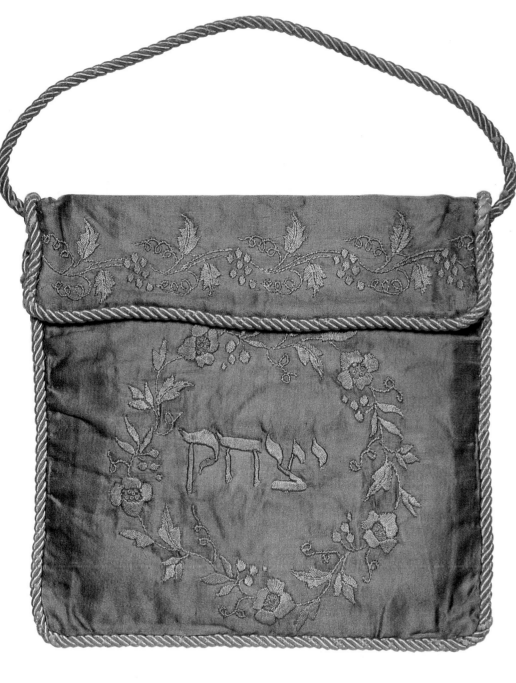

In the past, the religious obligations of Jewish women were centered only around the home, thus they did not receive the formal religious education that men typically enjoyed. Today, many Jewish girls do receive training and celebrate a *bat mitzvah*, although the ceremony for girls was only instituted at the beginning of the twentieth century. Many of the traditions associated with the *bar mitzvah* still apply only to boys.

For both boys and girls, the day is marked by their first reading from the Torah, when the child is considered to become an integral member of the community. At this time, a boy acquires two important possessions that symbolize his commitment to Judaism. The first is the *talit*, a prayer shawl with fringes at the corners (*tzitziot*) for using during morning prayers. A boy also receives *tefilin* at his *bar mitzvah*: leather cubes, also called phylacteries, which enclose parchment strips containing passages from the Torah, and are also worn during morning prayers.

Customary gifts for the *bar mitzvah* include silver boxes to hold *tefilin* and protect the leather when they are not being used, as well as beautifully embroidered and decorated velvet bags for both *tefilin* and *talitot* (the plural of *talit*).

After the Torah reading at the synagogue, it is popular today to have a party to celebrate, which can range from a small gathering at home to a black-tie event for hundreds either at the synagogue or another location. Since 1967, when the Western (Wailing) Wall reverted to Israeli control, it has become a popular tradition to hold the *bar mitzvah* ceremony at the Wall.

Another relatively new practice—that of confirmation—originated in the nineteenth century with German Reform congregations that substituted confirmation at the age of sixteen or seventeen for the *bar mitzvah* at thirteen. The idea at the time was that older teenagers would be better equipped to become full members of the community.

Today, although many stop their formal Jewish education after their *bar* or *bat mitzvah*, for those in Conservative and Reform congregations who do go on, they celebrate their confirmations at age fifteen for both boys and girls. The celebration is typically held on *Shavuot*, the holiday associated with the giving of the Torah on Mount Sinai.

**Talit Bag**

*1870, Philadelphia; satin weave silk embroidered with silk thread, lined with silk damask; border and handle of silk cord; 9 x 8 3/4 in. (23 x 22.5 cm). The Jewish Museum, New York.*

A common *bar mitzvah* gift was a bag to keep the *talit* in when it was not being used. This one was made and embroidered by Charity Solis-Cohen for the *bar mitzvah* of her brother, Isaac Leeser Cohen.

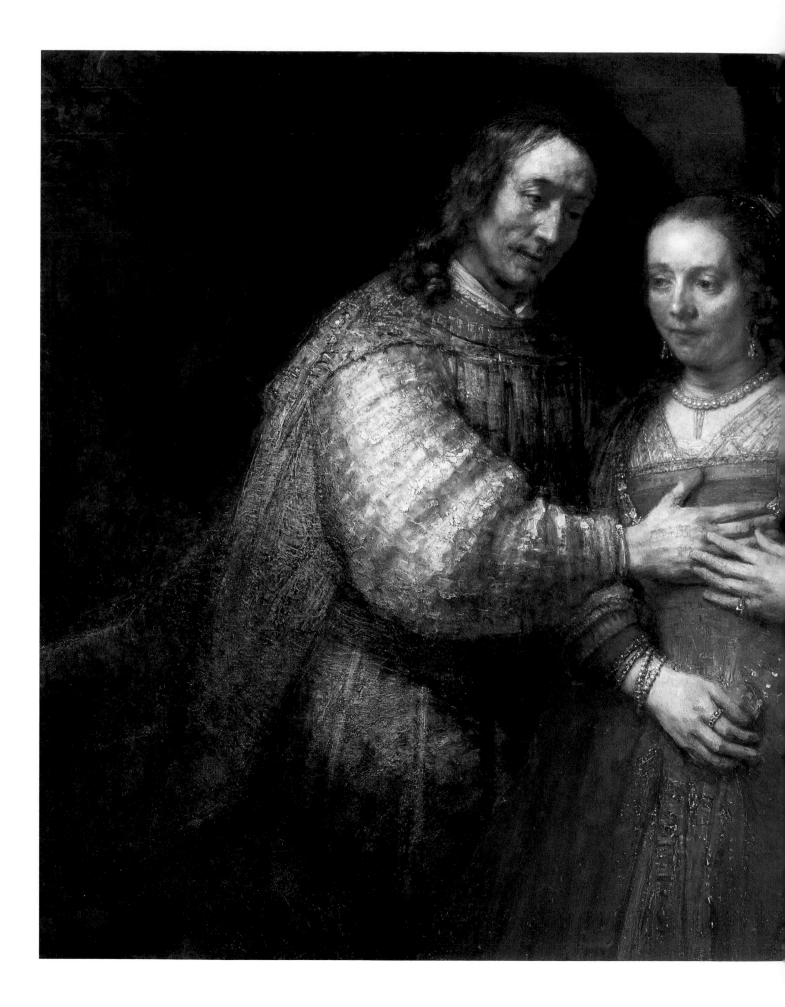

## The Wedding Day

Arguably one of the most important events in the life of a Jew, the wedding day begins the transformation of two individuals to a family, one of the critical tenants of Jewish life. The Jewish view of marriage can be summed up by a line in the Talmud: "One who does not have a wife lives without joy, without bliss, without happiness." (Yevamot 62b)

The wedding day itself, in addition to being a time of joy and celebration, takes on a solemn tone with the signing of the *ketubah*, essentially a contractual agreement that states the personal and financial obligations of the groom to his bride. So old that its origins are murky—the oldest one found to date is from the fifth century B.C.E.— the *ketubah* is still used by all Jewish communities in one form or another.

As a symbol of this most important milestone, the making of *ketubot* has become an artform in itself, reaching its most ornamental level by Italian artisans of the seventeenth and eighteenth centuries. Written on either paper or parchment, *ketubot* are personalized with the names of the participants and place and date of the wedding. Other decorations include animal and floral patterns, biblical figures, Jewish motifs, and micrography—the art of minuscule writing to form elaborate patterns and designs.

While the *ketubah* is used by all Jews, other wedding traditions vary. For example, the ultra-Orthodox wedding might take place under the stars at night, while a more modern wedding could be held anywhere from a synagogue to a hotel ballroom. In most cases, the ceremony itself is performed under a *chupah*, or wedding canopy, another tradition whose origins are unclear. Parents and attendants usually join the couple under the *chupah* for the ceremony.

Traditionally the *chupah* is a large piece of decorated silk, satin, or velvet, supported by four poles.

### The Jewish Bride

*Rembrandt van Rijn (1606–1669), 1668; oil on canvas;*
*47 1/2 x 65 in. (121.5 x 166.5 cm). Rijksmuseum, Amsterdam.*
This painting is the best-known of Rembrandt's
works entitled *The Jewish Bride*, which include an earlier
etching and a drawing. Despite the name, none of the
traditional accouterments of a Jewish wedding are present
in the painting to confirm that the couple is Jewish.

Its exact use varies, as in the case of the poles, which might be inserted into the ground, held aloft by the groomsmen, or, as in the case of military weddings today in Israel, replaced with hand-held rifles. The *chupah*, too, can be individualized: A tradition dating from seventeenth-century France and Germany uses the groom's *talit* (an outgrowth of when the groom would spread his *talit* over his bride's head as a symbol of protection), while a modern couple might purchase a *chupah*, have one made, or choose a cloth of sentimental value, such as a beloved grandmother's tablecloth.

The actual dress of the couple typically takes on the customs of their society: A groom might wear anything from a white *kittel* (a simple white robe that symbolizes purity) to a tuxedo; a traditional bride will cover her face with a veil while others choose not to.

In the past, the ring given by the groom to the bride at the wedding itself was often a ceremonial ring belonging either to the family or the community, and was later replaced by a plain band. Today, the ring given is typically the one the bride wears for the rest of her life; as in other religions, the modern bride usually also gives her groom a ring.

At the end of the ceremony, the groom breaks a glass (today it is often a light bulb) by stepping on it. Numerous reasons are given for the breaking of the glass, most related to the concept of remembering that even life's most joyous moments must be tempered with sorrow. Some relate the custom to an expression of sorrow over the destruction of the Temple, while others say the noise was originally intended to ward off evil spirits. Sephardic Jews then shout out *Siman tov* ("good omen"), while Ashkenazic Jews use the words *Mazel tov* (literally "good star," based on the ancient belief in astrology; the words now convey the sense of "good luck").

**Traustein**

*c. 1700, Bingen, Germany; red sandstone; 18 x 24 1/4 in. (46 x 62 cm).*

*Israel Museum, Jerusalem.*

In the middle ages, grooms would break a wineglass at the end of the wedding ceremony by throwing it against a wall. In Germany, the custom evolved into throwing the glass against a special stone called a *traustein*, which was built into an exterior wall.

**The Jewish Cemetery**
*Jacob Ruisdael*
*(c. 1628–1682), 1653–1655;*
*oil on canvas; 32 x 37 1/2 in.*
*(82 x 96.2 cm). Detroit*
*Institute of Art, Michigan.*
Ruisdael, one of the most
celebrated Dutch land-
scape painters, recorded
a Sephardic Jewish burial
ground in Ouderkerk,
near Amsterdam, in draw-
ings and etchings, which
became the inspiration
for this painting. The
ruins and brewing storm
produce a romantic sense
of melancholy for the
temporary nature of
humanity, increased by the
artist's signature on the
tombstone at the front left.

## Death and Mourning

Jewish death rituals, while centered around respect and dignity for the deceased, also encompass concern for the welfare of the living. One of the most obvious ways this is seen is that Jewish Law dictates burial within twenty-four hours of death; if this is not possible, because, for example, of family members having to travel to attend the funeral, the time is extended to three days.

Another example was the formation in the past of societies, known as *Hevra Kaddisha* ("Holy Society") to ensure proper burial for their members. Dating from Talmudic times, these societies (whose other functions were to care for the sick and provide for the poor) typically met once a year on the seventh day of the month of *Adar* (the traditional anniversary of the death of Moses). After a day of fasting, a sumptuous banquet was held and wine was passed around in large silver or glass wine cups. The cups, decorated either with the names of

the members of the society or showing funeral processions, mourners, and other representations of death ceremonies, exist primarily in museums today.

Another remnant from the societies are alms boxes, of brass, metal, or silver, often in the form of tombs or gravestones, which were used for making contributions at funerals, a practice that dates from the Bible (Proverbs X:2): "Alms giving delivers from death." The tradition lives on today with the giving of contributions to charities in the name of the deceased. Friends and neighbors also provide food for the mourning family; flowers, while not encouraged, are not expressly forbidden.

The concept of a wake or viewing the deceased does not exist in the Jewish religion; today close family members might, however, choose to pay their last respects before the coffin is closed for the funeral. The biblical custom of a close mourner—spouse, parents, or children—

tearing his or her garments has been replaced with the wearing of a black ribbon so that clothing is not ruined.

Most families observe the seven-day period of mourning called *shiva* ("seven" in Hebrew), although more Orthodox practitioners might extend the time to thirty days. In a traditional household, mourners sit on low stools and cover all mirrors, practices no longer followed by more reform Jews. During the period when the mourners are sitting *shiva*, relatives and friends come by the house to pay a condolence call and help the mourners work through the loss of a loved one.

At any point after *shiva*, the tombstone may be erected, although in most instances a period of about a year is first observed. Today's tombstones tend to be relatively simple and decorated with typical Jewish symbols, such as a Star of David, *menorah*, Sabbath candles, *shofar*, or tree of life, and perhaps a Hebrew inscription in addition to the person's name and birth and death dates. Throughout history, Jewish tombstones have

alternated between very simple, stark monuments and those that were more elaborately decorated, such as those of Sephardic communities, which used more representational art: angels, biblical scenes, even a skull and crossbones.

A custom begun at the end of the nineteenth century in England and the United States involves covering the newly erected tombstone with a veil. A close family member uncovers the tombstone at the "unveiling" ceremony, when the tombstone is first seen officially. A purely symbolic ceremony, the unveiling does not require any religious presence.

In keeping with the importance of respect for the deceased, the next of kin light a *yahrzeit* candle every year on the anniversary of death (following the Hebrew calendar). While permanent *yahrzeit* sconces exist from the past, today's mourner is more likely to use an inexpensive special glass with a candle inside designed expressly for *yahrzeit* or even an electric candle. The deceased are also remembered during *yizkor* (memorial) services in synagogue on major holidays.

**Burial Plaque**

*4th–5th century C.E., Italy; incised marble. Gift of Mr. Samuel Friedenberg, The Jewish Museum, New York.*
In the same way a tombstone for a late twentieth century American might include both English and Hebrew inscriptions, this ancient Roman burial plaque reads "Here lies Flavius the Jew" in Latin and "Peace" in Hebrew. Even today, the decorations of the *menorah, lulav,* and *shofar* remain common Jewish symbols.

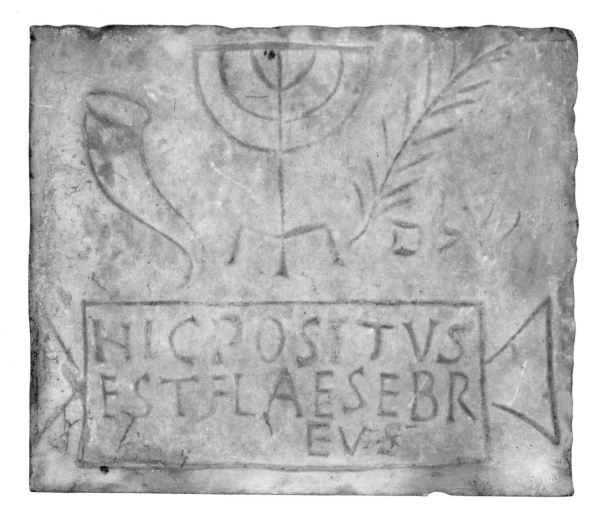

**Memorial (*Yahrzeit*) Lamp**

*Moshe Zabari (b. 1935), 1972; silver and glass. The Jewish Museum, New York.*
Once a year, on the Hebrew anniversary of a death, the next of kin light a memorial, or *yahrzeit*, candle to keep the memory of the deceased alive. The hands on this lamp might be the two hands often seen on the grave of a *Kohen*, descendants of the priestly family, which represent the conferring of the priestly benediction.

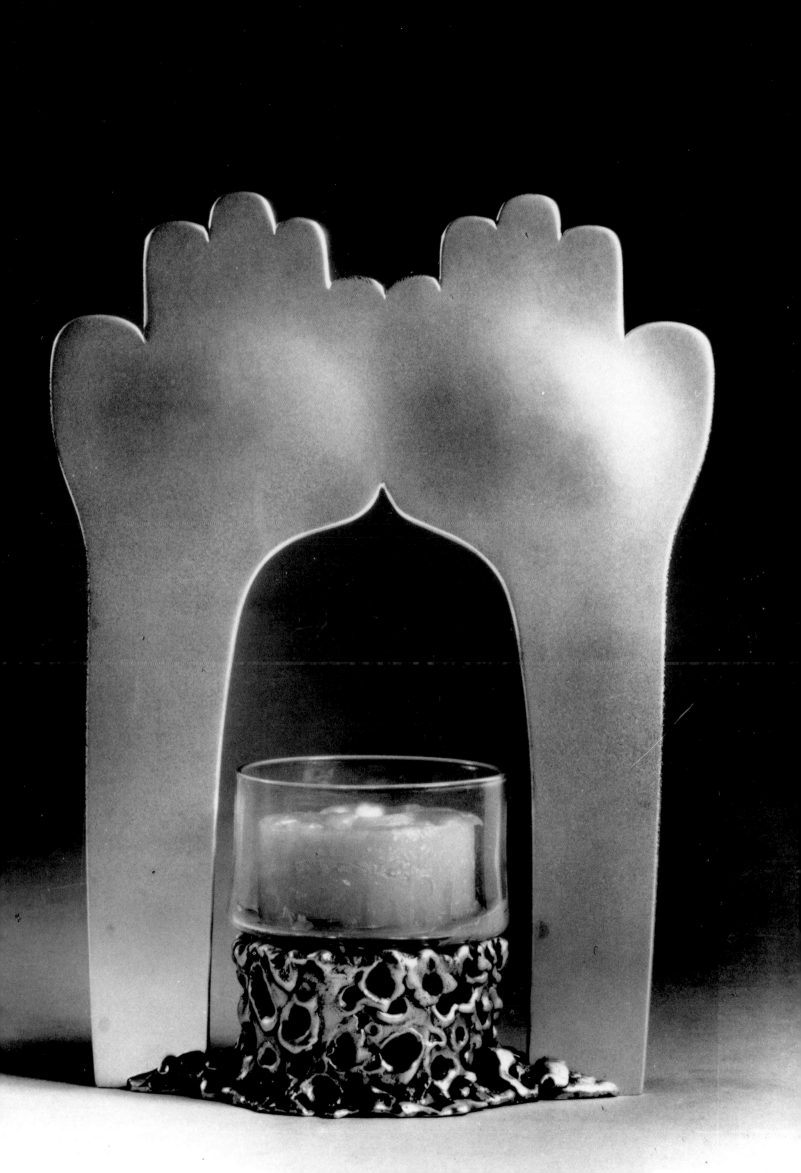

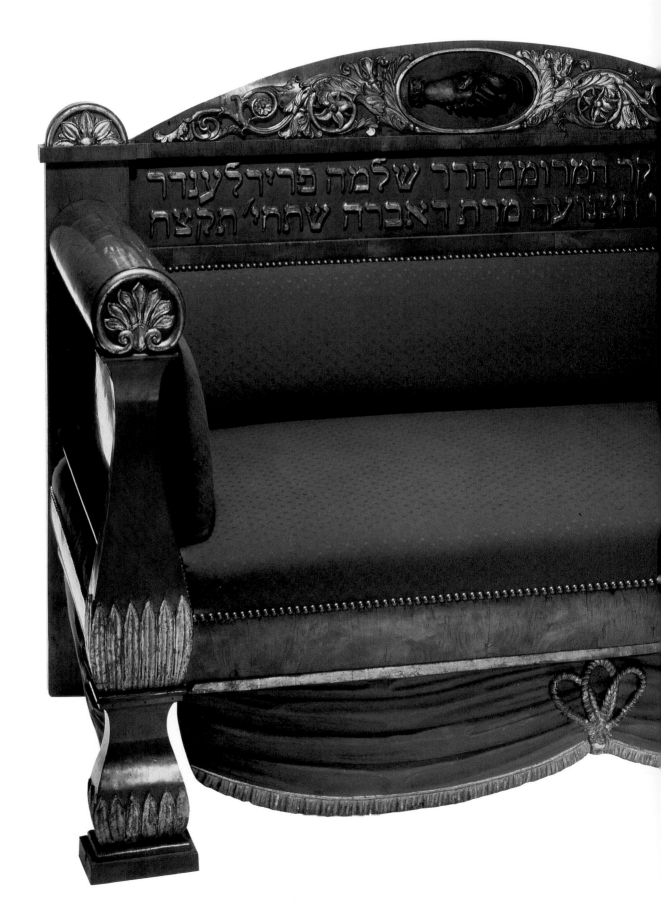

**Wedding Sofa**

*1838, Northern Germany, possibly Danzig; birch veneer over pine, lindenwood, painted and gilded, upholstered; 38 1/4 x 63 x 28 in. (97 x 160 x 71 cm). Gift of the Danzig Jewish Community, The Jewish Museum, New York.*
An example of the Biedermeier style of furniture-making, this is possibly the only remaining example of a wedding sofa. The two clasped hands at the top signify the wedding union; the Hebrew inscription tells the donor of the sofa and the year.

## Wimpel

*M. Metzger, 1924 (made for Judah ben Isaac); undyed cotton, painted;*
*118 x 8 in. (302.5 x 20.5 cm). The Jewish Museum, New York.*
In parts of Germany, it was common to cut a baby's swaddling
cloth into four parts and sew these together to form a *wimpel*
(torah binder), which was donated to the synagogue on the child's
first visit. This *wimpel* is decorated with Jewish symbols and scenes of
holidays and milestones, including a *bar mitzvah* and wedding *chupah*.

## Chair of Elijah

*18th century, Alsace; walnut and deal. Musée Alsacien, Strasbourg.*
In the ninth century B.C.E., the prophet Elijah fought for the reinstitution of the circumcision ceremony after foreign influences had caused its lapse. To honor Elijah, Jewish law requires that an empty chair be reserved for the prophet at every circumcision. The godfather would sit on one side of this bench, holding the baby, while the other side is left empty for Elijah.

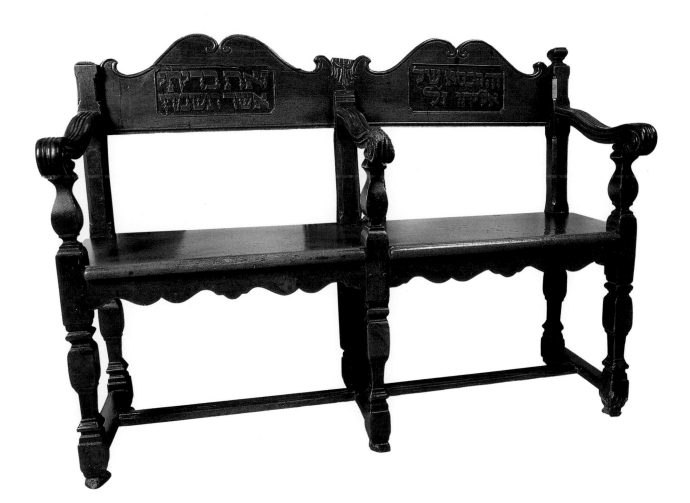

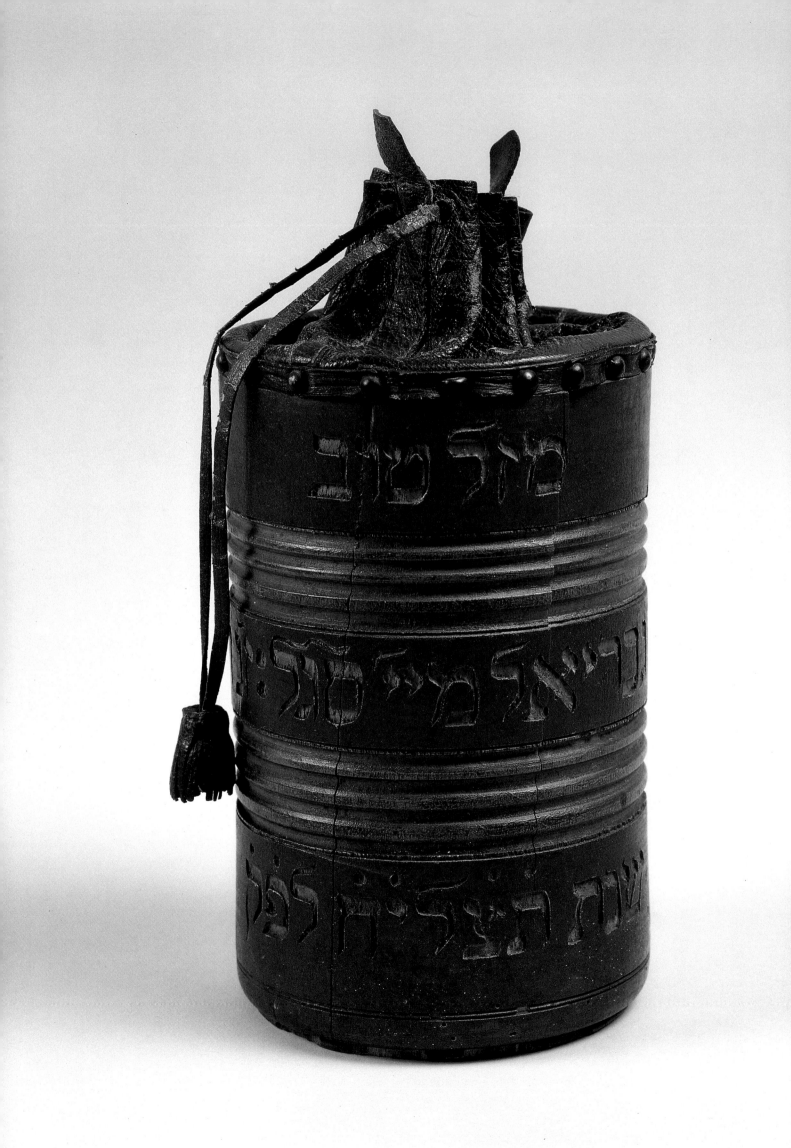

### Jewish Wedding

*18th century, Italy; copper engraving.*
*Israel Museum, Jerusalem.*
The bride and groom stand
together outside, both covered
with the groom's *talit* (prayer shawl).
They are under the *chupah*, or wed-
ding canopy, whose poles are held
by the attendants. One man holds
the *ketubah* (marriage contract)
and another carries the wine glass
from which the couple will drink.

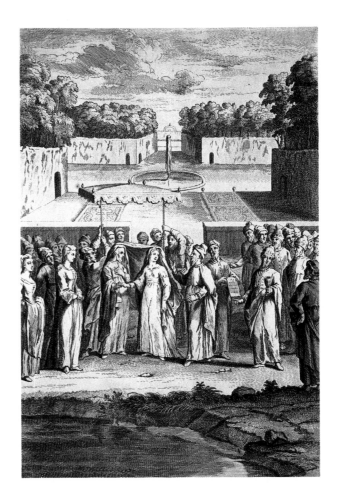

### Collection Bag

*1778, Strasbourg; painted wood and leather. Musée Alsaçien, Strasbourg.*
In keeping with the Jewish tradition of donating monies on
weddings and other joyful occasions, special bags and boxes
evolved to collect the contributions. The inscription on this bag says
"good luck" and that it was donated by "Wolf, son of Gabriel May of Alsace."

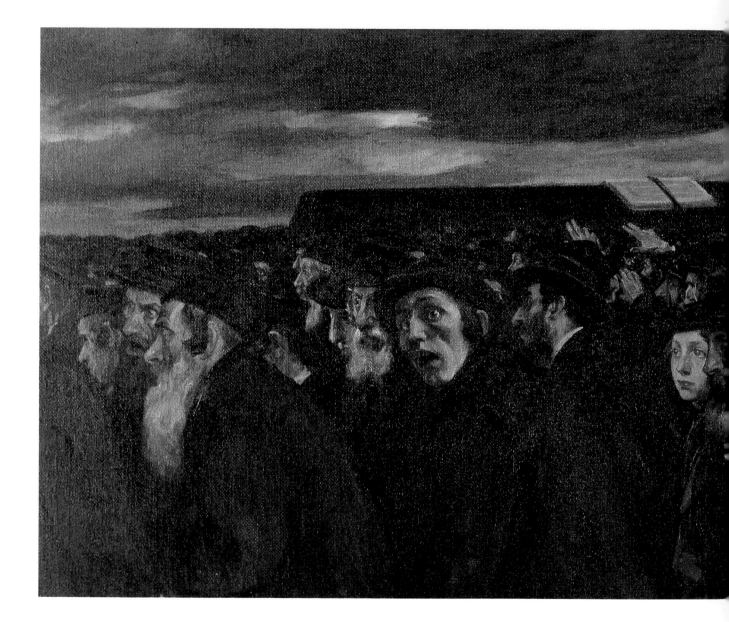

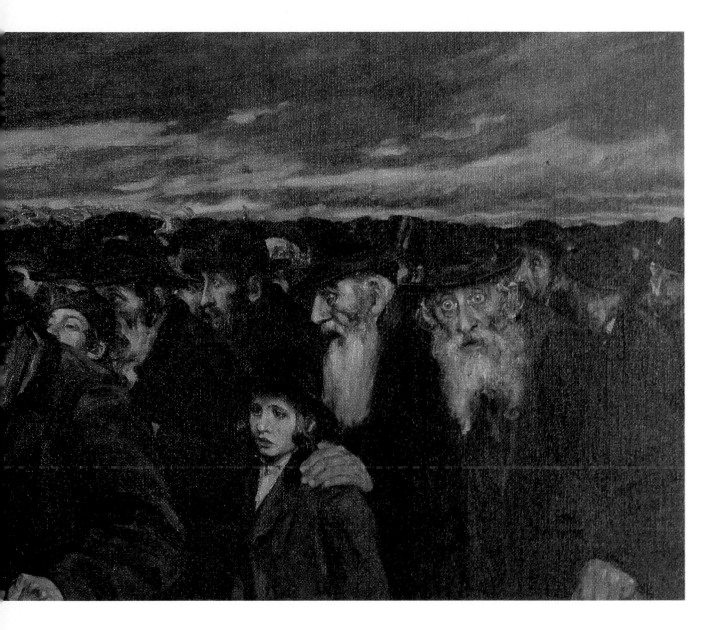

**The Black Banner**

*Samuel Hirszenberg (1865–1908), 1905; oil on canvas;*
*30 x 81 in. (76.2 x 205.7 cm). The Jewish Museum, New York.*
Also called *Funeral of the Zadik*, the long horizontal composition, overcast sky, and dark
colors of this painting convey the sense of grief this Hasidic community feels as they
carry their leader to his resting place. The title *Black Banner* also reflects political events
of the time in Poland and Russia, especially the increase in pogroms and anti-Semiticism.

## Ketubah

*1864; Utica, New York; watercolor and ink on paper;*
*12 1/2 x 9 1/2 in. (32 x 24.5 cm). Library of*
*the Jewish Theological Seminary, New York.*
This relatively modern American *ketubah*, or
marriage contract, retains the architectural columns
popularized by the extremely ornamental seventeenth-
and eighteenth-century Italian *ketubot*. The grandfather
clocks at the top of the columns illustrate the written
wish, "Let it be a propitious hour," while the handshake
highlights the contractual nature of the agreement.

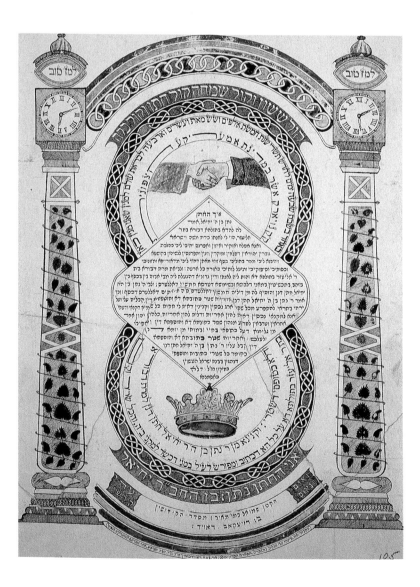

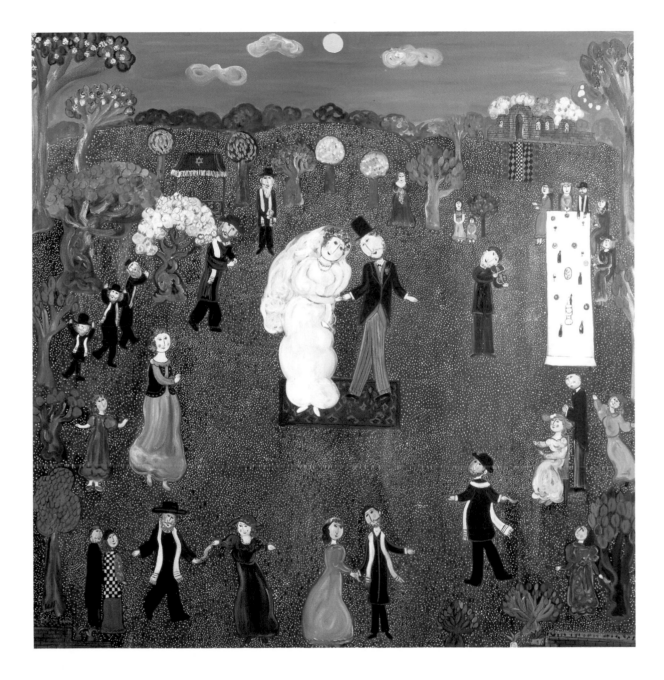

**Dancing at the Wedding**

*Dora Holzhandler, 20th century; Rona Gallery, London.*
Whether indoors or outdoors, a large part of the reception
after the wedding ceremony revolves around dancing. At
today's weddings, modern dances are interspersed with
folk dancing, such as the popular circle dance, the *hora*.

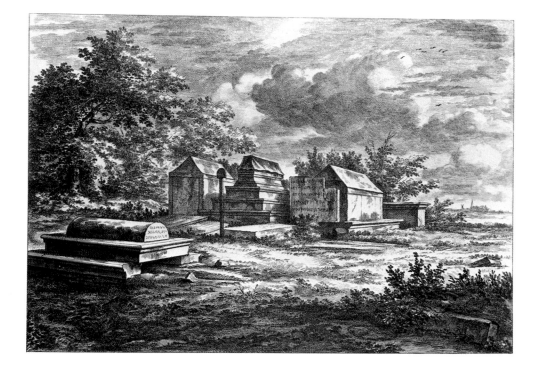

**Jewish Burial Ground**

*Abraham Bloteling, 1670; engraving*
*and etching. Israel Museum, Jerusalem.*
The unusual design of the oldest
tombs at Ouderkerk, recorded by
Jacob Ruisdael, captured the imagina-
tion of Bloteling, as well as the
Dutch artist Romeyn de Hooghe; both
made prints of Ruisdael's drawings.

## Wedding Rings

*16th and 17th centuries;*
*Italy; Musée de Cluny, Paris.*
These gold rings, which belonged
either to a family or the community
at large, were lent to the bride for
her wedding day; later the groom
would give the bride a plain band.
The rings were commonly decorated
with "MT" standing for *mazel tov*
(good luck); topped with buildings
(sometimes the Temple of Jerusalem), or
inscribed with the marriage benediction.

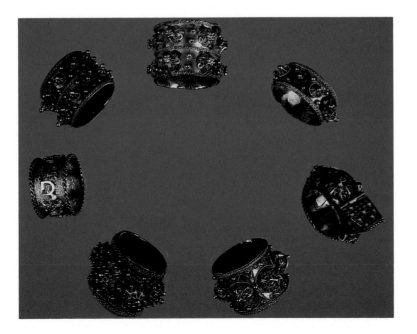

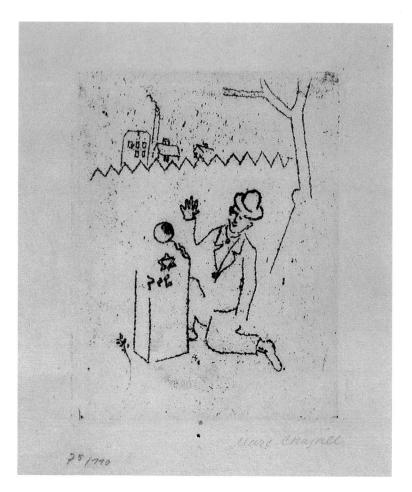

### Beside My Mother's Tombstone

*Marc Chagall (1887–1985),*
*1922; etching; 4 1/2 x 3 3/8 in.*
*(11.4 x 8.6 cm). The Jewish Museum, New York.*
Seen kneeling beside his mother's tombstone, Chagall's
raised hand might have just dropped clumps of grass
on the grave, a custom that originated in medieval
times as a safeguard against evil spirits. Visitors to a
grave also place stones on the tombstone as a symbolic
act to show they have not forgotten the deceased.

### Beakers of the Burial Society of Worms

*Johann Conrad Weiss (active*
*1699–1751), 1711–1712; silver,*
*parcel-gilt, engraved; 9 3/4 x 4 1/3*
*in. (24.8 x 12.5 cm).* Gift of
Michael Oppenheim, Mainz,
The Jewish Museum, New York.
To ensure proper burial for
members of the community,
societies were formed called
*Hevra Kaddisha* (Holy Society).
The sides of these beakers
are inscribed with the names
of the members of the
Burial Society of Worms.

הגאון הגדול
אבד מוהר״ר דוב
שטריים נרומפף
שלמה פולדא
אברהם רייכש
מיכאל מנהיים
נטע לובשיטיץ
הירץ וואכנהיים
הרד מאיר טולר
הרד ברהר טולל
ברהר טולר
סענדל הגניק
הדל ליב שבכשטט
אהרן בר מרדכי
זנוויל רייבש

שנת לפ״ק
אפי׳ בהרב
אברהם
פייב מלהי
ואלף בהרר
יצחק אייזק
ז״ל
שמעון בן
הרר שמואל
זנוויל
גערסטנל
הרד שלמה בן
פו מוהר״יאב
מנהיגים
מאיר בן הרר
משה זצ״ל
פ׳אלם בר

אברהם קאבלענ

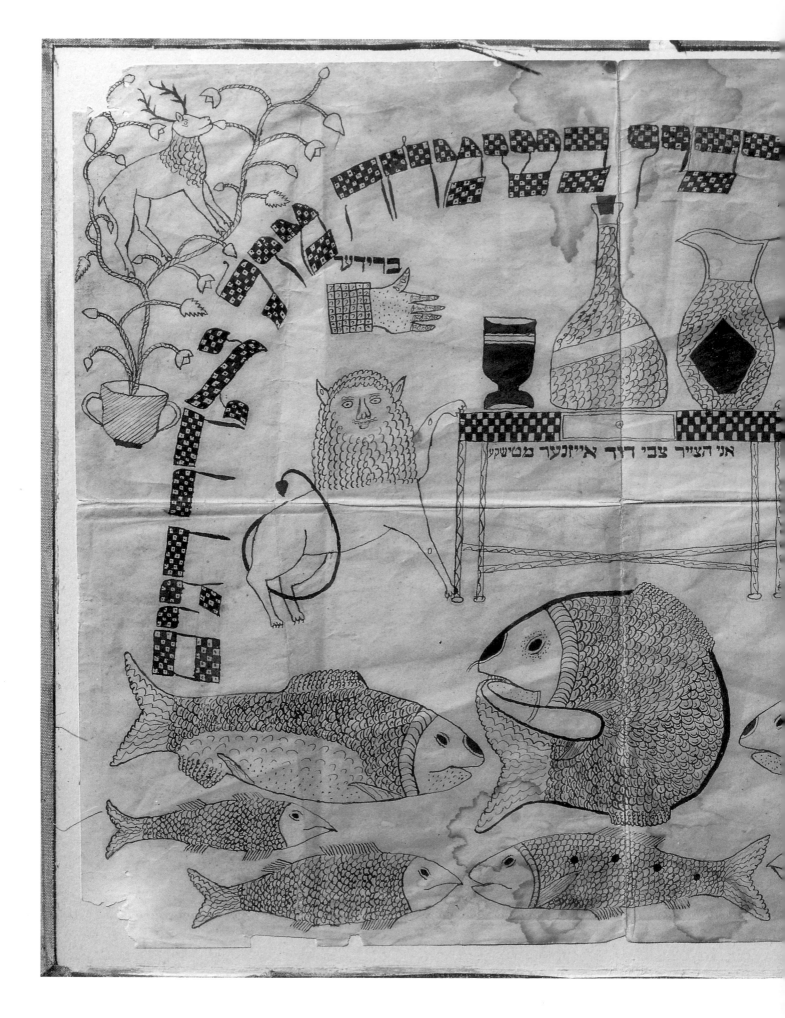

אני הצייר צבי דוד אייזנער ממטישקע

# THE JEWISH CALENDAR AND BIBLICAL HOLIDAYS

The festivals of the Jewish year stem from many traditions. Most have roots in ancient pagan and agricultural celebrations, revised to incorporate the history and philosophies of the ancient Israelites. To this day, holiday practices continue to evolve, with new religious rituals and cultural customs entering into tradition. Artists throughout the centuries have commemorated important religious and historical events—as historic records, for aesthetic pleasure, and to decorate the items that came to be associated with the holidays.

## The Jewish Calendar and *Rosh Chodesh* (The New Moon)

The Jewish calendar was not fixed until the middle of the fourth century C.E. Until that time, the arrival of each new moon, *Rosh Chodesh*, dictated the beginning of each month. The Jewish calendar was, and remains, a lunar calendar, with monthly cycles of twenty-nine or thirty days. The sighting of the new moon had to

**Adar Folk Calendar**
*Tzvi David Eisner, late 19th century, Poland or Russia; paper; 16 1/4 x 13 in. (41.5 x 33.5 cm). Jüdisches Museum der Schweiz, Basel.*
This calendar for the month of *Adar*, in the early spring, combines Jewish and other motifs that symbolize the month. The fish represent the astrological sign of Pisces, which occurs at the same time, while the wine decanter, pitcher, and cup symbolize the festive holiday of Purim, celebrated in the month of *Adar*.

**The Adoration
of the Moon**
*Max Weber
(1881–1961), 1944; oil
on canvas; 48 x 32 in.
(121.9 x 81.2 cm).
Whitney Museum of
American Art, New York.*
Weber drew on his
memories as a child in
Russia for this paint-
ing, which shows
Hasidic men reciting
the blessing for the
new moon. Against
the background of the
modern city, the men
continue to celebrate
the ancient ritual.

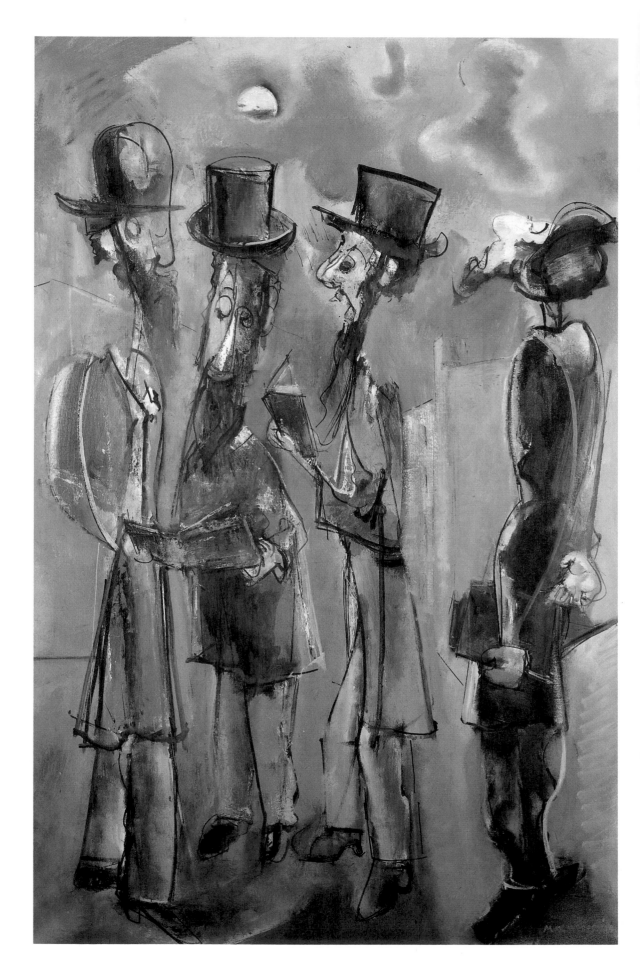

be attested to by two witnesses who would appear before the Sanhedrin, the supreme judicial body of Jewish life. The news of the new month would then be passed on to other communities via a system of torches and messengers.

The unreliable nature of these systems created a problem, especially as Jews moved further from Palestine. If Jewish communities did not receive the news of the new moon on the correct day, they would start the month on the wrong day—and therefore celebrate all festivals and holidays on the wrong day of the month. In response, Jewish authorities added one day to most major holidays of the Jewish calendar, reasoning that one of the two days of celebration would fall on the correct date. The calendar was put in its present form and distributed to all Jewish communities in 359 C.E.

The Jewish day always begins at sundown, based on Genesis: "And the evening and the morning were the first day." Because the Jewish calendar is lunar, based on the revolutions of the moon around the Earth, and the civil calendar is solar, adjustments are made to the Jewish calendar to bring it more in line with the solar calendar. The month of *Adar* II is added seven times in every nineteen-year period, and the number of days in certain months are reduced and increased as needed. Still, the Jewish calendar never exactly matches the solar calendar, which is why the holidays, based on the Jewish calendar, vary each year of the solar calendar.

Orthodox and most Conservative congregations in the Diaspora continue the practice of a two-day celebration for most holidays, while Reform Jews generally do not. Those in Israel have, for the most part, reverted to one day of celebration.

The celebration of the new moon lost most of its importance with the establishment of a standard calendar, although special prayers remain in its honor. Today, the new moon is noted most by the *Hasidim*, a devout sect founded at the end of the eighteenth century, whose emphasis is tradition and communion with nature. In recent years, some women have returned to the celebration of the new moon as a spiritual reminder of the feminine aspect of Judaism.

## *Pesach* (Passover)

The first of the major Jewish festivals mentioned in the Bible, *Pesach*, or Passover, is also the most popular, celebrated by more Jews than any other holiday. The eight-day holiday (seven days in Israel) commemorates the freedom of the Israelites after more than four hundred years of bondage in Egypt. Passover is both a joyous tribute to freedom and a solemn reminder of past oppression.

The focal point of Passover, which is celebrated in the month of *Nisan*, is the *seder*, a highly ritualized meal that takes place in the home the first (and sometimes the second) night of the holiday. Hebrew for "order," the *seder* follows the order prescribed in the Passover prayer book, the *haggadah*.

Containing biblical quotations, stories, songs, and prayers, the *haggadah* fulfills the biblical

**Seder Plate**

*c. 1450, Spain; majolica (glazed earthenware); 22 in. diameter (56.5 cm). Israel Museum, Jerusalem.* This Hispano-Mauresque plate, thought to be from before the expulsion of the Jews from Spain in 1492, contains orthographic errors in the Hebrew lettering. Scholars speculate that the errors are because the plate was made by a non-Jew or possibly by the descendent of a *converso*—a Spanish Jew who was forced to convert to Christianity—who continued to secretly practice his faith.

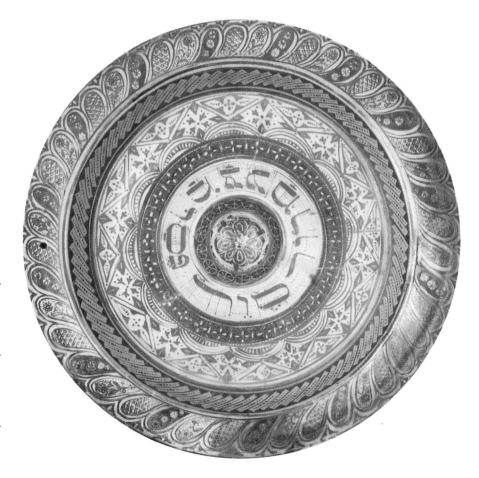

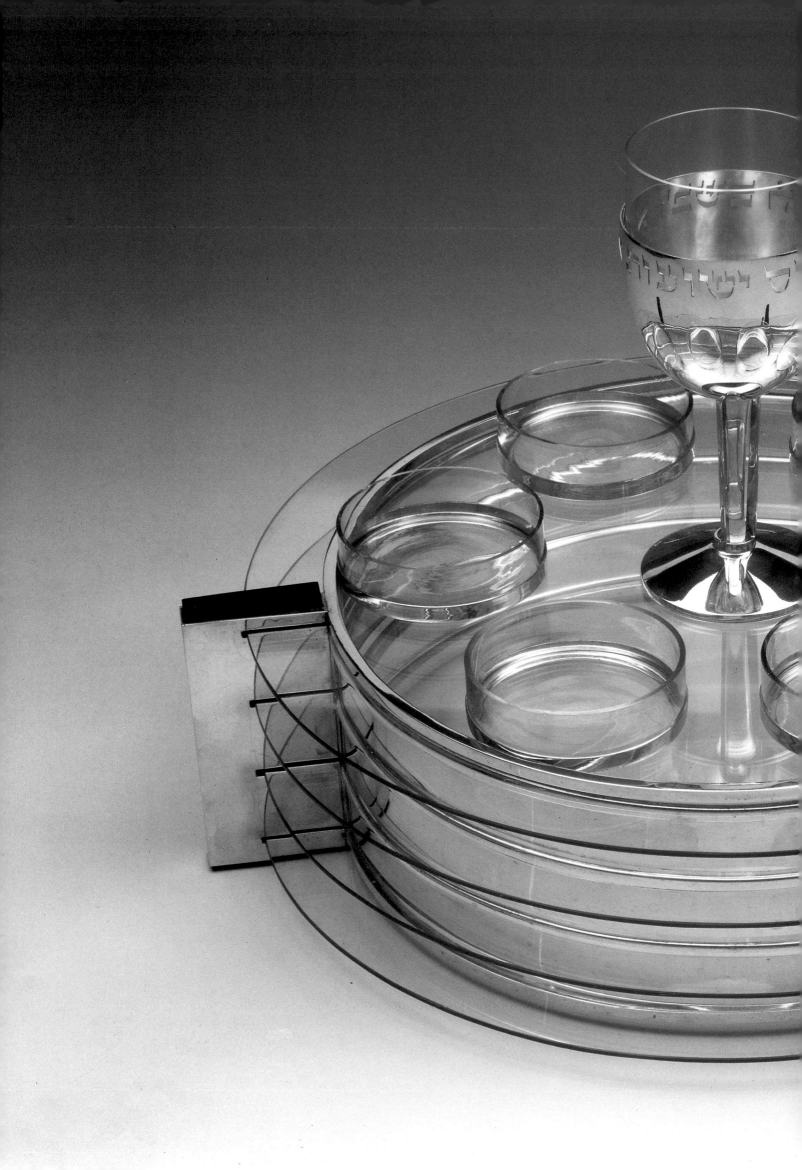

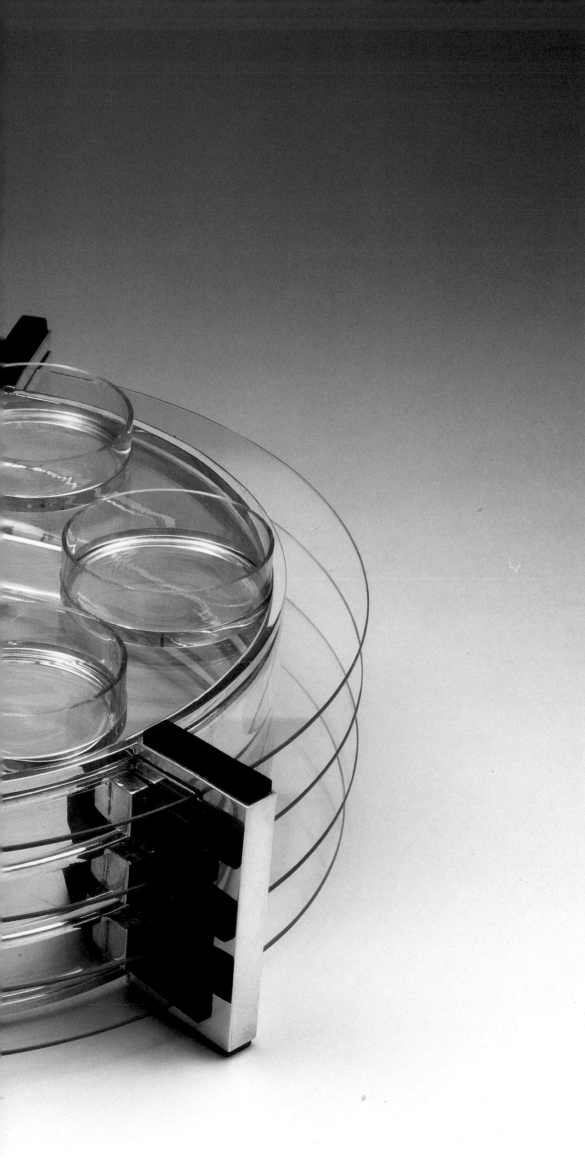

**Tiered
Passover Set**
*Ludwig Wolpert
(1900–1981), 1930;
silver, ebony, and glass;
10 in. high x 16 in.
diameter (25.4 x 40.6
cm). Promised gift of
Sylvia Zenia Wiener,
The Jewish Museum,
New York.*
Considered the first
to apply the Bauhaus
principle—that form
and function are
mutually dependent—
to Jewish ceremonial
art, Wolpert based
the form of this set
on earlier Passover sets.

## Preparations for the Passover Festival

*Etchings from Bernard Picart's* Cérémonies et Coutumes Religieuses; *1725. Rijksmuseum, Amsterdam.* This page shows two common Passover scenes of Sephardic Jews. Top: The night before Passover, family members search for leavened bread, left intentionally for the ceremonial hunt and burning the next day. Bottom: The family is gathered for the Passover meal, and the table set with all the necessary foods for the *seder*.

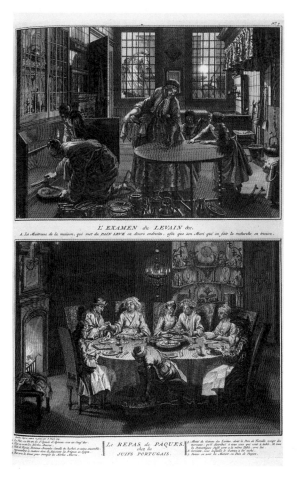

injunction to tell the story of the Exodus from Egypt and its related miracles to children. To ensure that children would pay attention during the long readings before the actual meal, *haggadot* developed as the most decorated of all Jewish books. Everyone reads aloud from the *haggadah*, which is used only during Passover and only in the home.

The main ceremonial object used during the *seder* is the *seder* plate or tray. Made of silver, brass, pewter, carved wood, glazed ceramic, or glass, the trays are frequently decorated with scenes depicting Passover, visions of the Holy Land, and inscriptions from the *haggadah*.

Most have compartments for the five symbolic foods eaten during the meal: *zeroa* (roasted lamb bone, symbolic of the Passover sacrifice), *beitzah* (roasted egg, referring to the festival sacrifice in the Temple and the loss of the two Temples that stood in Jerusalem), *maror* (a bitter herb, such as a horseradish root, indicating the bitterness the Israelites endured during their slavery in Egypt), *karpas* (a vegetable such as parsley which symbol-

izes rebirth), and *haroseth* (chopped apples and nuts mixed with spices and wine; the mixture looks like mortar and is to recall the time when the Israelites were forced to make mortar in Egypt). Some plates contain a sixth indentation for *chazaret*, a second bitter herb such as cucumber or watercress.

The *seder* plate is sometimes tiered to hold and separate the required three pieces of *matzah*—the flat, unleavened biscuits that replace bread during Passover. If the pieces of *matzah* are not placed on a tiered plate, they are covered either with a napkin or a special cover, made of cloth, velvet, or silk brocade, sometimes decorated with scenes of Passover.

One of the three pieces of *matzah* is broken before the meal and set aside to be eaten after the remainder of the meal. This piece, called the *afikomen*, is used to entertain and keep the attention of children during the *seder*. Either the children "steal" the *afikomen* and hide it for the *seder* leader to find, or the leader hides it for the children to find. In either case, the leader pays a "ransom" to have the *afikomen* returned so it can be eaten at the end of the meal.

Part of the Passover ritual involves either using completely different dishes during Passover or putting them through a ritual cleaning that makes them kosher for Passover. (Reform Jews typically do not do this). Some families have special Passover *kiddush* cups, made of silver or glass, which are decorated with Passover scenes or inscriptions from the *haggadah*. A special cup is also set aside for the prophet Elijah, whose return is awaited to herald the time of the Messiah. The cup is filled with wine to show Elijah he is welcome at all Passover celebrations; participants also open the door for Elijah to demonstrate their willingness to have the prophet and the foretold time of peace and harmony enter their lives.

### Haggadah

*14th century, Spain. British Museum, London.* The page of this illuminated *haggadah* shows the Hebrews building cities for Pharaoh to illustrate the scriptural verse "They put upon us heavy work."

כְּמָה שֶׁנֶּאֱמַר וַיָּשִׂימוּ עָלָיו

שָׂרֵי מִסִּים לְמַעַן עַנֹּתוֹ

בְּסִבְלֹתָם וַיִּבֶן עָרֵי מִסְכְּנוֹת

לְפַרְעֹה אֶת פִּתֹם וְאֶת

רַעַמְסֵס

## *Sefirah*
## (Counting the *Omer*)

In addition to commemorating the Exodus from Egypt, the roots of the Passover holiday can be found in ancient agricultural celebrations: Passover marked the beginning of the grain harvest. In Leviticus, the Torah commands that on the second day of the holiday, the first crop, barley, is to be cut and an *omer* ("measure") of barley brought to the Temple as a sacrifice. It was forbidden to eat of the new crop until the *omer* was offered on Passover.

Leviticus 23:15 states: "And from the day on which you bring the sheaf of wave offering . . .you shall count off seven weeks . . ." Thus a biblical connection of forty-nine days was established between the holiday of Passover and the next biblical agricultural holiday of *Shavuot*, which begins on the fiftieth day after the second day of Passover. The entire period became known as *Sefirah* or "counting" the *omer*.

Special calendars were written to incorporate the blessing recited each night and the counting of the days and weeks. Typically hand-written and decorated on parchment by professional scribes, *omer* calendars feature such typical Jewish decorations as the *menorah* and Star of David. Many also include themes of plants and flowers in remembrance of the agricultural basis of the holiday. To this day, some people buy flowers or plants each week during this time.

There is no reason stated in the Bible for the link between Passover and Shavuot, although an agricultural connection is implied. Later, when Shavuot evolved from an agricultural holiday to one that commemorates the giving of the law at Mount Sinai, Talmudic scholars found a symbolic connection: The freedom that started with the physical liberation from slavery in Egypt at the time of Passover was not fulfilled until the spiritual liberation that came with receiving God's law at *Shavuot*.

**Omer Calendar**

*18th century, Holland; painted wood. Israel Museum, Jerusalem.*
Next to each of the forty-nine days of the *Omer* period, there is an empty hole for placing a peg to keep count of the days. The blessing recited before the counting of the *omer* is inscribed in Hebrew in the center.

### Shavuot (Pentecost)

As the plural of the Hebrew word for "week," the very name *Shavuot* marks its connection with Passover, which precedes it by seven weeks. However, in addition to the "Feast of Weeks," the Bible refers to the holiday as the "Festival of the First Fruits" and the "Harvest Festival." Later, it also came to be known as "Pentecost," Greek for "holiday of fifty days." The holiday falls on the sixth day of *Sivan*, which occurs anytime from late May to June. In Israel and among Reform Jews, the holiday is observed for one day; Jews in the Diaspora celebrate for two days.

In biblical times, the one-day festival in late spring signified both the end of the grain harvest and the beginning of the first fruits of the land. In addition to Passover and *Sukkot*, *Shavuot* was one of three Jewish pilgrimage festivals—times when Jews from all over Palestine would make the pilgrimage to the Temple in Jerusalem. A special sacrifice of two loaves of bread was made at the Temple on *Shavuot* and another sacrifice, of the first fruits, was made anytime between *Shavuot* and *Sukkot* (the end of the harvest).

After the destruction of the Temple in 70 C.E., when there was no longer a site for the sacrifices, the holiday started to lose its significance. Later, in Talmudic times, scholars calculated that the events at Mount Sinai took place at the time of *Shavuot*, and the festival started to take on new meaning. Today, the holiday represents Moses receiving the Torah at Mount Sinai and is a time for the affirmation of Judaism. It is also considered the conclusion to Passover: Together, Passover, the count-

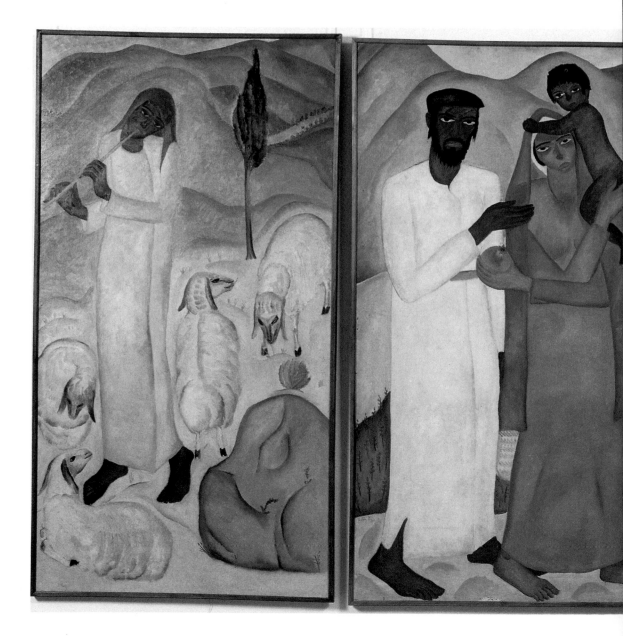

ing of the Omer, and Shavuot represent the physical and spiritual liberation of the Jews.

Its agricultural roots continue to permeate the holiday, however, which in part led to the tradition of decorating synagogues and homes with greenery, such as plants, branches, and flowers, especially roses. Such decorations in turn inspired the Eastern European art of paper-cutting, and during *Shavuot*, the windows of synagogues and homes were decorated with papercuts that involved complicated designs of trees, flowers, and other traditional Jewish folk themes.

Other, more recent traditions, have also evolved around the holiday. For example, in synagogue, the Book of Ruth is the traditional reading today, making the analogy between Ruth, who adopted Judaism, and Jews, past and present, who accept

the Torah handed down to Moses at Mount Sinai.

At the end of the nineteenth century, Reform Judaism introduced the concept of "confirmation" and now in Reform, Conservative, and some Orthodox synagogues, *Shavuot* is the time when both boys and girls confirm their allegiance to a Jewish way of life through their Confirmation. Other traditions include eating special foods, such as *challah* with a ladder on its top; cheese-filled triangular *kreplach*; two cheese *blintzes* to represent the two tablets of the Ten Commandments; and dairy and honey, so that the words of the Torah are experienced as pleasant. In Israel today, the holiday has reclaimed some of its agricultural associations, and the first fruits are given a place of honor amid processions, singing, and dancing.

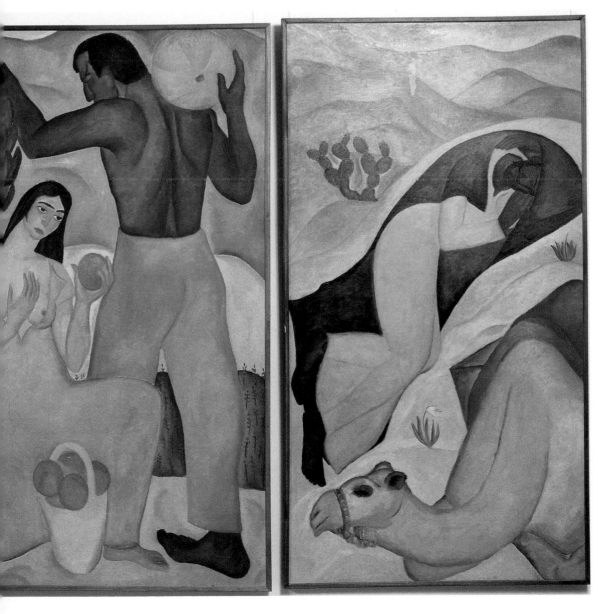

**First Fruits**
*Reuven Rubin
(1893–1974), 1923;
oil on canvas; 71 x 82 in.
(188 x 202 cm).
Rubin Museum
Foundation, Tel Aviv.*
Rubin, who settled in Palestine in 1922, was a pioneer in the development of a distinctly Israeli style of Jewish art. Here, the simplified figures and bright colors, reminiscent of French naïfs such as Henri Rousseau, share the promise of the first fruits and the land of Palestine.

**Shofar**

*19th century, probably
Ethiopia; ram's horn and coral;
24 1/2 in. (62.9 cm).
Gift of Harry G. Friedman,
The Jewish Museum, New York.*
The trumpetlike blasts of
the *shofar* had many uses in
addition to being blown
on *Rosh Hashana* and *Yom
Kippur*. Other functions
includes the announcement
of war, the intimidation of
an enemy, and the call to
public assembly, a function
it still serves in Israel today,
in additional to heralding
the beginning of the Sabbath.

## Rosh Hashana
## (Jewish New Year)

Literally the "head of the year," *Rosh Hashana*
ushers in the most solemn time of the Jewish
year, the Jewish New Year and, ten days later, *Yom
Kippur* or the Day of Atonement. Together, the
two are referred to as the "High Holidays" or the
"High Holy Days" and mark the beginning and
end of a ten-day time of reflection. They are also
part of the "Days of Awe" period, which actually
begins with the new moon of the month before
*Rosh Hashana*, *Elul*.

Unlike most other Jewish holidays, *Rosh
Hashana* has no agricultural or historical signifi-
cance; it is referred to in the Bible as a festival,
although the notion of the "new year" might
have developed later. The Jewish calendar actual-
ly includes four times that are considered the
"new year"; *Rosh Hashana* is the beginning of the
religious year, although it occurs in the fall in the
seventh month, *Tishri*, of the Jewish civil calen-
dar (which begins in the spring).

At the beginning of the new year, each per-
son's actions are judged by God, who renders a
final decision on *Yom Kippur*. The days between
the two holidays are used for solemn reflection
of the past year. In a sense, though, the start of
the period of contemplation actually begins a
month before *Rosh Hashana*. The "Days of Awe"

period commences with the
Sabbath before the new moon
of the month of *Elul*. From that
day on, at every weekday morn-
ing service, the *shofar* is sounded
until *Yom Kippur* as a call to
repentance and spiritual regen-
eration.

One of the most ancient wind
instruments known to humans,
the *shofar* is a hollowed-out
horn of an animal of the sheep
or goat family. It is most com-
monly the horn of a ram, per-
haps as a reminder of the bibli-
cal binding of Isaac, when
Abraham prepared his son as a
sacrifice to God but was spared
by the substitution of a ram.
The horn is soaked in extremely hot water
until it becomes flexible enough to be flattened
and curved. As an artform, the *shofar's* beauty lies
in its simplicity; it is forbidden to decorate a *sho-
far* with pictorial representations or painting or
to cover its mouthpiece with metal. Carved
inscriptions are permitted, and those few
remaining *shofars* with biblical inscriptions are
rare and highly prized. In some cases, in addition
to biblical passages referring to the *shofar*, they
are inscribed with the donor's name or informa-
tion about the congregation for whose use it
was made.

Aside from heralding in the new year, the
*shofar* is mentioned several times in the Bible:
Its primary uses were to intimidate an enemy,
call citizens to war, or gather the public to
assembly. Its trumpetlike blasts were sounded to
herald the appointment of a king, announce
the start of festivals, warn of impending nation-
al disasters such as flood, announce the passing
of a funeral, and signify other events of public
importance. The Bible recounts how the walls
of Jericho fell flat when *shofars* were sounded.
In Israel today, it is still blown regularly before
the Sabbath begins and before public
announcements and national events.

The *shofar* is a common Jewish motif, used to
decorate a range of items from mosaic floors in

synagogues to ceramic oil lamps, from seals and rings to tombs. It is said that the long-awaited coming of the Messiah will be heralded by the prophet Elijah sounding his great *shofar* of redemption. Hebrew books and medieval illuminated manuscripts often show the Messiah approaching the walls of Jerusalem on a donkey and sounding the *shofar*.

The *shofar* is sounded each day in the month preceding *Rosh Hashana* to alert Jews to start taking stock of their lives. On the two days of *Rosh Hashana* (one for Reform Jews), some congregations sound one hundred blasts of the *shofar*. Its sound also closes the period of reflection at the end of *Yom Kippur*.

For observant Jews, the focal point of *Rosh Hashana* is the synagogue, rather than the home.

The lengthy morning services (anywhere from two to seven hours depending on the congregation) stress the return to God, who is willing to forgive each person's sins and offers the opportunity to begin the new year with a clean slate. The gates of repentance remain open until *Yom Kippur*, when the final decree is established. Typically the Birth and Binding of Isaac is commemorated in the *Rosh Hashana* readings as an example of devotion to God.

Folk customs of the holiday mostly concern foods: Honey and other foods prepared with honey are common, in the hope that they will help usher in a "sweet" new year. In addition to New Year's greetings and expressing the hope for a good year in person, many Jews send cards to express such wishes to family and friends.

**Moses and Aaron**

*Aaron de Chavez (d. 1705); oil on canvas. Spanish and Portuguese Jews' Congregation, London.* De Chavez was the first recorded Jewish painter to work in England. Here, Moses and Aaron stand next to the tablets of the Ten Commandments, written in both Hebrew and Spanish. The painting originally hung over the Torah ark in the Creechurch Lane Synagogue.

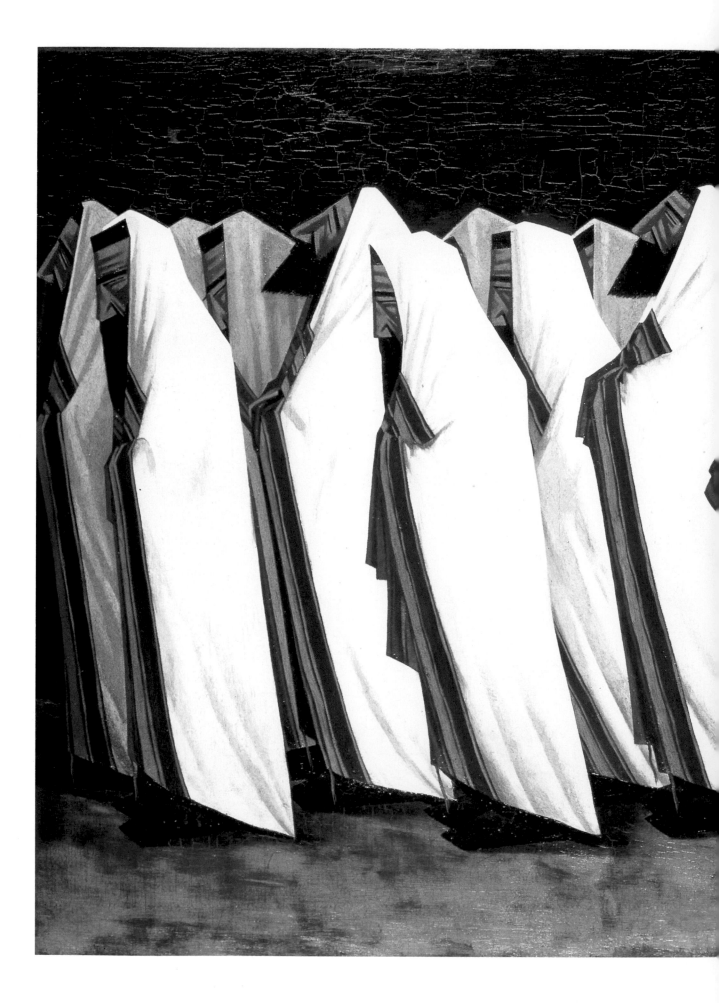

## Yom Kippur
## (Day of Atonement)

For many Jews, *Yom Kippur*, or the Day of Atonement, has taken on the hallmark of the most holy day of the year, although in actuality the weekly Sabbath surpasses it in importance. Even Jews who celebrate few holidays or other rituals of Judaism tend to participate in the fasting and overall abstinence required of *Yom Kippur*.

As with all Jewish holidays, *Yom Kippur* begins at sunset, although two aspects of it actually begin before sunset. A full meal is eaten before sundown to prepare the body for the following twenty-four hours without food. In addition, those who wear prayer shawls don them before sunset; the *Kol Nidre* service that marks the beginning of the holiday at synagogue is the only time prayer shawls are worn other than for morning services.

The ritual of *Yom Kippur* is centered around the synagogue, and most of the day is spent in prayer and contemplation, aided by the abstinence from food, drink, and other bodily "pleasures," such as bathing, sex, and the wearing of leather. As a day of fasting, prayer, contemplation, and overall abstinence, *Yom Kippur* is not associated with any forms of ritual art, except perhaps by their absence. In some congregations, men and women dress in white to symbolize purity and humility, and the traditional colored ark curtains, torah mantles, and reader's covers may be replaced with white ones.

A man who wears a loose white holiday robe or *kittel* sometimes accompanies it with a special holiday belt, to separate the lower part of the body (associated with bodily functions) from the upper part (associated with the heart and the mind). The belt is typically made of silver and decorated with Jewish symbols and perhaps inscribed with a prayer.

At the end of *Yom Kippur*, the *shofar* is given one last long blast, signalizing the end of the day of fasting. Families then usually gather to break the fast together with a meal.

### Day of Atonement

*Jacob Kramer (1892–1962), 1919; oil on canvas; 39 1/4 x 48 1/8 in. (99.6 x 122.4 cm). Leeds City Art Galleries, Leeds.*
Against a stark background, the congregation stands in silent prayer. The simplified figures and repetition reflect elements of Cubism. With its sparse colors and lack of detail, the painting seems to echo the universal and solemn nature of the holiday itself.

## Sukkot (Festival of the Tabernacles)

From the solemn contemplation of *Rosh Hashana* and *Yom Kippur*, Jews move quickly to the celebratory festival of *Sukkot*, a mere five days after *Yom Kippur*, on the fifteen of *Tishri* in late September or early October. *Sukkot* is the third and last pilgrimage festival, and concludes the story of the Israelites, which begins with their Exodus from Egypt on Passover and the giving of the Law at Mount Sinai on *Shavuot*. The seven days of *Sukkot* commemorate the forty years that the Jews wandered in the wilderness after leaving Egypt and the protection afforded to them by God during that time.

The holiday stems both from agricultural origin—celebrating the coming of autumn and the final gathering of produce before winter—and biblical commandment: "You shall live in booths seven days . . . in order that future generations may know that I made the Israelite people live in booths when I brought them out of the land of Egypt . . ." (Leviticus 23:42–43)

The very name *Sukkot* is derived from the Hebrew word for "booth," *sukkah*, which Jews build each year for the festival. The holiday is also referred to as the "Festival of the Booths" and "Tabernacles," which is the Latin word for "hut" or "temporary shelter."

Constructed between *Yom Kippur* and *Sukkot*, the *sukkah* is the central focus of the holiday. In the past, it was a temporary structure built by each individual family, where the family would eat, study, and sleep for the seven days of *Sukkot*. In today's society, only the most observant of Jews continue to construct their own *sukkah* and even those who do, do not necessarily "live" in the *sukkah*. Synagogues, however, have continued the tradition, with congregations working together to build larger communal *sukkot*, where members can eat and study if they so choose.

The *sukkah* is a temporary structure built in the open air. The roof should be covered enough with branches so that there is more shade than sunlight, but not so covered that the stars cannot be seen at night. Walls, made of canvas or other cloth, paneling, or wood, are attached to a frame and decorated. A *sukkah* can be as simple or elaborate as one chooses, although they tend more to the latter in keeping with the theme of rejoicing and celebration. The most simple decorations are fruits and vegetables and paper ornaments such as chains and crepe paper.

The style of ornamentation depends in large part on the location and ancestry of the people doing the decorating. An eighteenth-century Italian tradition, for example, used paper decorations that incorporated texts and images, while in other countries, velvet and other materials were used to form more elaborate wall plaques. Images often center around the text of Ecclesiastes, read in synagogue during the holiday, and pictures of Jerusalem and the Holy Land.

**Etrog Box**

*c. 1670–1680; Augsburg, Germany; silver gilt, hammered and chased; 7 1/2 x 9 in. (19.1 x 23 cm). Gift of Dr. Harry G. Friedman, The Jewish Museum, New York.* Boxes were used to protect the *etrog* (citron) during the seven days of the *Sukkot* festival when the *etrog* was carried between home and synagogue. The containers were often formed in the shape of the fruit itself, such as this one.

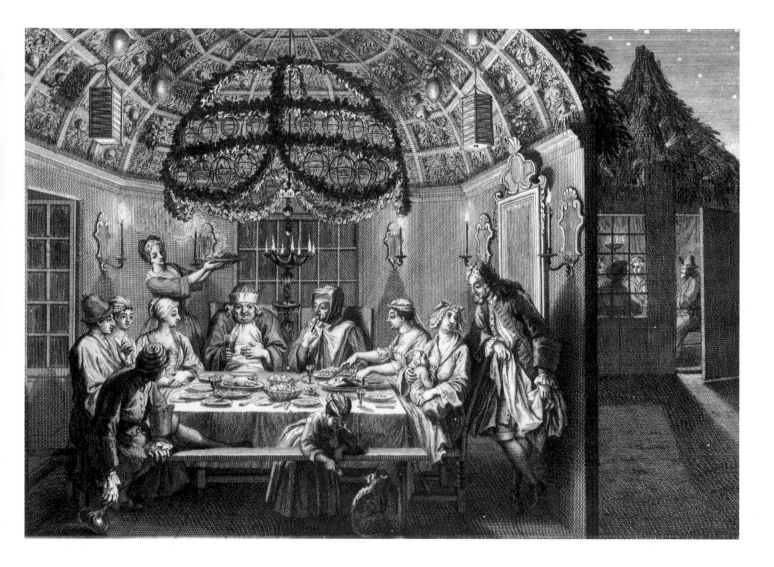

Other traditions have grown around the biblical instructions to rejoice with the four "species," interpreted as *lulav* (palm branch), willow, myrtle, and *etrog*, or citron, a strongly scented lemon-colored citrus fruit grown mostly in the Middle East. During *Sukkot* services in synagogue, participants hold the *etrog* in one hand and the *lulav*, bound together with the myrtle and willow, in the other. At prescribed points, they are moved in all directions. All four of these objects were common motifs in ancient Jewish art, such as synagogue mosaic floors and gold glasses and coins, as well as more modern pieces of ritual art.

In addition, special containers were developed to protect the delicate citron when it was not in use. Called *etrog* boxes or containers, the earliest known boxes were made in Germany in the seventeenth century. Of silver or silver-plated brass, the decorative boxes tended to echo the oval shape of the fruit itself, and were often set on a base in the form of a leaf or a section of a larger branch. Both halves of the container were lined to cushion and protect the skin of the *etrog*.

During the eighteenth century, oval and rectangular containers, which were probably used to hold sugar at other times of the year, came into use to protect the *etrog* during *Sukkot*. Some were decorated and some were not; it is not difficult to differentiate those that were used for this purpose from regular sugar boxes. A later tradition of boxes on raised bases developed from artists working in the Holy Land in the nineteenth century. These boxes, often decorated with filigree and semi-precious stones, were carved and painted with views of Jerusalem, biblical scenes, and the traditional symbols of *Sukkot*. Modern Israeli artists make similar boxes, although in other places the boxes tend now to be simple containers of wood or cardboard.

**Festive Meal in the Sukkah**

*From an engraving by Bernard Picart; 1722. Rijksmuseum, Amsterdam.* The *sukkah* in the front is so richly decorated, it could easily be mistaken for a permanent room in a house. The family has gathered for a meal, eaten in the *sukkah* during the seven days of *Sukkot*. In the background, a less ornate *sukkah* houses a family not so well off, perhaps their servants.

**Sukkah**

*1825, Fischach, Germany; painted wood; 9 1/2 x 9 1/2 feet; 82 in. high (2.90 x 2.90 meters; 210 cm high). Israel Museum, Jerusalem.* This classic *sukkah* was first erected in the south of Germany for family members to dwell in during the holiday of *Sukkot.* The walls are painted with scenes from the village of Fischach, where the family lived, and the artist's vision of Jerusalem. Branches, fruits, and vegetables cover the roof.

84

### Mizrach

*18th century, southern Germany;*
*ink and watercolor on paper;*
*13 1/2 x 9 in. (34.5 x 23 cm).*
*Israel Museum, Jerusalem.*
A *mizrach* ("east") hangs in some
homes to indicate the direction
of Jerusalem, which Jews should
face during prayer. The center
panel reads: "From this direction
comes the spirit of life." It is
surrounded by eight panels with
scenes depicting Jewish holidays.

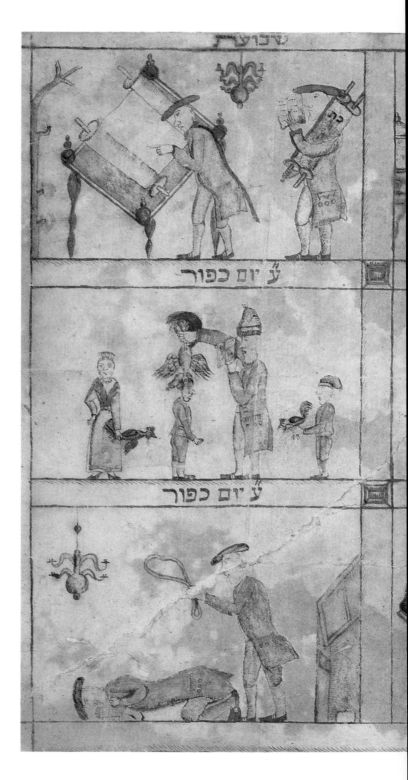

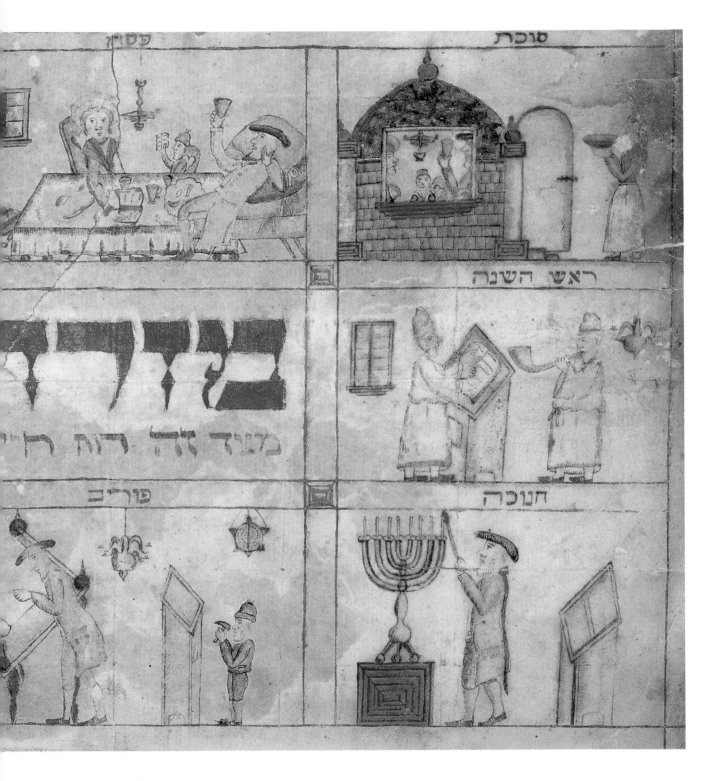

### Omer Calendar of Moses Mendelssohn

*c. 1780, Germany; pen and ink and gouache on parchment; 26 1/2 x 3 1/2 in. (67.3 x 8.9 cm). Gift of Dr. Harry G. Friedman, The Jewish Museum, New York.*

The Hebrew inscription on the bottom reads: "To the beloved and esteemed Moses Mendelssohn." The writings of Mendelssohn (1729–1786), both a practicing Jew, as illustrated by this personalized *Omer* calendar, and a pioneer of the German Enlightenment, brought a clearer understanding between the Jewish world and that of the Gentile.

**Zodiac Table**

*518–27 C.E., Israel; stone mosaic. The Jewish Museum, New York.*
Through the centuries, Jewish mysticism has included the
study of astrology. The signs of the zodiac, each labeled in
Hebrew, are arranged around the sun in his chariot in the center.

### Jewish New Year's Greeting

*Attributed to Happy Jack (c. 1870–1918), 1910; engraved walrus tusk with gold inset; 10 x 1 in. diameter (25.4 x 2.5 cm). Gift of the Kanofsky family in memory of Minnie Kanofsky, The Jewish Museum, New York.*

The first permanent Jewish settlement was established in Alaska in 1885. Although carving walrus tusks is a centuries-old tradition, "Happy Jack," a native Alaskan, is credited with the introduction of engraving walrus tusks with a very fine needle, such as this Jewish New Year's Greeting. The Hebrew inscription is the traditional New Year wish: "May you be inscribed for a good year, 5671 (1910)."

**Illustration from *Had Gadya* Suite (*Tale of a Goat*)**
*El Lissitzky (1890–1941), 1919; colored lithograph on paper;*
*10 3/4 x 10 in. (27.3 x 25.4 cm). Promised gift of Leonard*
*and Phyllis Greenberg, The Jewish Museum, New York.*
An allegory for the oppression of the Jewish people, the *Had Gaya*,
an Aramic poem based on a German ballad, is chanted at the end
of the Passover *seder*. Although Lissitzky's drawings are connected
to a series of children's drawings, *Had Gaya* illustrations are most
frequently used to decorate *haggadot* (the texts for the Passover *seder*).

**Weighing and Delivering Matzot**

*1870, from Leslie's* Popular Monthly; *American Jewish Historical Society, Waltham, Massachusetts.* While workers prepare the *matzot*, a group of Jewish men and women wait their turn to purchase it. This was one of a series of pictures the magazine ran that showed the weighing, baking, and distribution of *matzot* in New York.

## Memorial Plaque and Omer Calendar
## of the Society for the Study of Mishnah of Beth Hamedresh Hagodol

*Baruch Zvi Ring (1870–1927), 1904; Rochester, New York; ink, gold, and silver paint, colored pencil, and watercolor on cut paper; 55 x 50 in. (130.7 x 127 cm). Gift of Temple Beth Hamedresh-Beth Israel, The Jewish Museum, New York.*
Born in Lithuania, Ring is one of many nineteenth-century Jewish immigrants who applied the traditional Eastern European art of paper-cutting to religious documents. This intricate work serves both as *Omer* calendar (the two outer circles) and a list of the names of the deceased members of the congregation, whose memory is honored by studying a portion of the *Mishnah* ("Oral Law") on the anniversary of death.

**Regensburg Pentateuch**

*c. 1300, Bavaria; illuminated parchment; 246 leaves;*
*9 1/2 x 7 1/4 in. (24.5 x 18.5 cm). Israel Museum, Jerusalem.*
In this medieval Pentateuch (the Five Books of Moses),
Moses is seen receiving the Tablets of the Law, descending
the mountain, and delivering the tablets to the waiting
Jews. The figures wear medieval clothing, including
the pointy caps compulsory for Jewish men of the time.

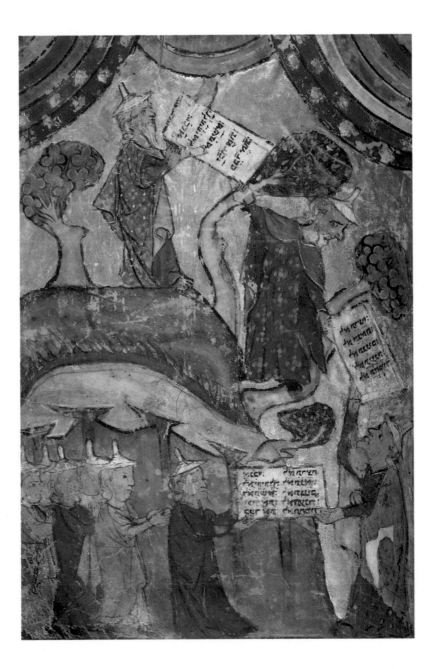

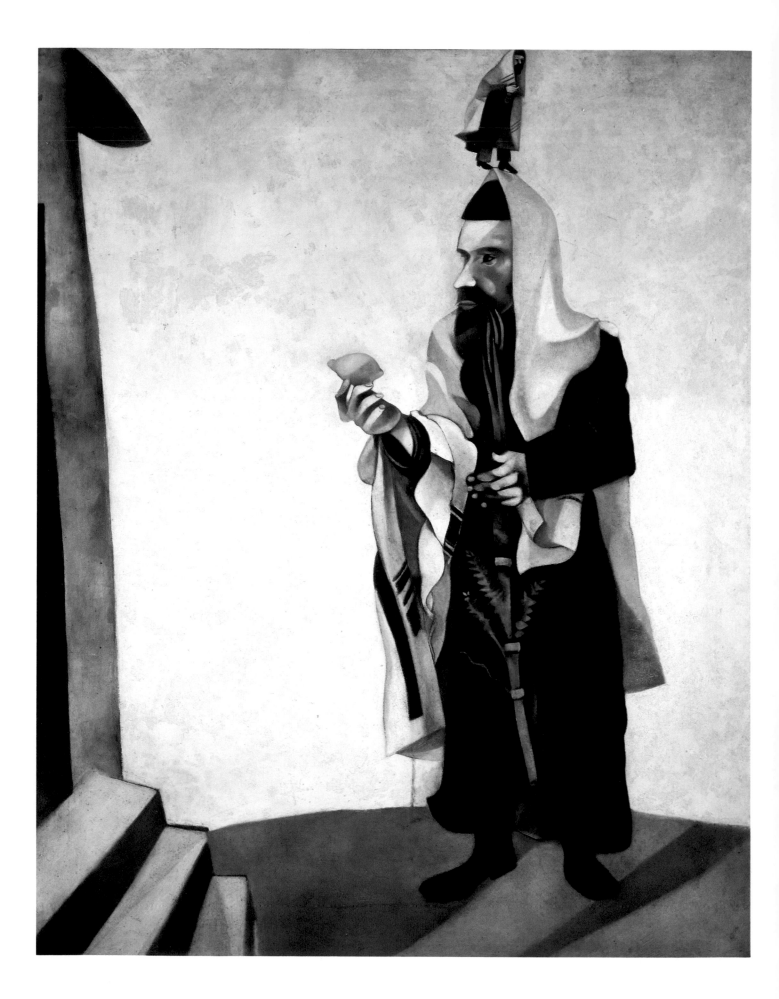

**The Rabbi with the Etrog**

*Marc Chagall (1887–1985), 1914; oil on canvas.*
*Kunstaamlung Nordrhein-Westphalen, Dusseldorf.*
From the *etrog* (citron) and *lulav* (palm branch tied with
myrtle and willow), it is clear the festival day of the
title is *Sukkot.* The meaning of the small figure on top
of the rabbi's head is open to interpretation—some say it
is his soul from which he has separated and turned away.

**Haggadah**

*15th century, Italy; illumination. Library of Congress, Washington, D.C.*
The scene from this illuminated *haggadah* depicts the traditional
roasting of the lamb for the Passover *seder.* (The text is the
conclusion to *Dayyenu,* a poem and song recited during the
*seder* meal. Approximately 150 medieval *haggadot* survive.)

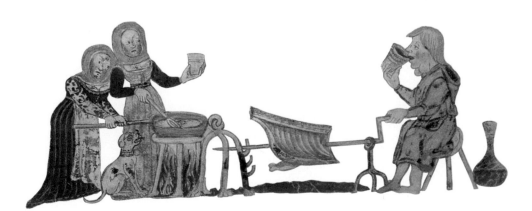

### The Call of the Shofar

*Ben Shahn (1898–1969), 20th century; mosaic mural;*
*Vestibule of Temple Ohabai Sholom in Nashville, Tennessee.*
Shahn imbued much of his work with Jewish themes and the
concept of equality for all people. The ram's horn *shofar* is
one of several Jewish symbols in this mural, which also include
the man's *talit* and the hand of God reaching from the flame.

### Sukkah Decoration

*Israel David Luzzatto (1746–1806),*
*c. 1775; ink and watercolor on paper;*
*20 x 15 1/2 in. (50.8 x 39.4 cm).*
*From the H. Ephaim and Mordecae*
*Benguit Family Collection,*
*The Jewish Museum, New York.*
With micrography (the art of
using miniature lines to form
images), the text of Ecclesiastes
is shaped as an astrolabe, an instru-
ment used to measure the sun's
altitude. There are several refer-
ences to the sun and its movement
in Ecclesiastes, the traditional
text read in synagogue on *Sukkot.*

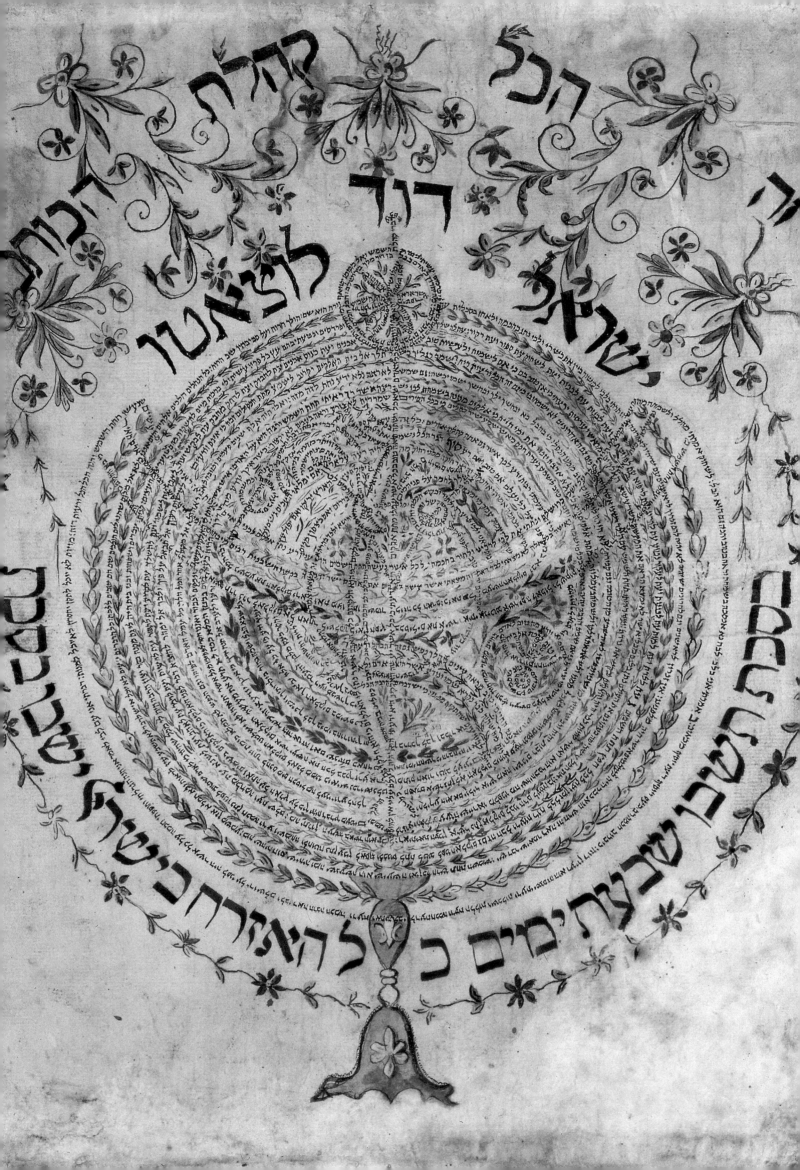

**Yom Kippur**
*Maurycy Gottlieb (1856–1879), 1878. Tel Aviv Museum, Israel.*
Although the Polish artist Gottlieb died at twenty-three, his prolific
work had already established him as a master Jewish portrait-maker.
Among the men and women shown here in prayer in their separate
sections on *Yom Kippur* is a self-portrait, to the right of the Torah.

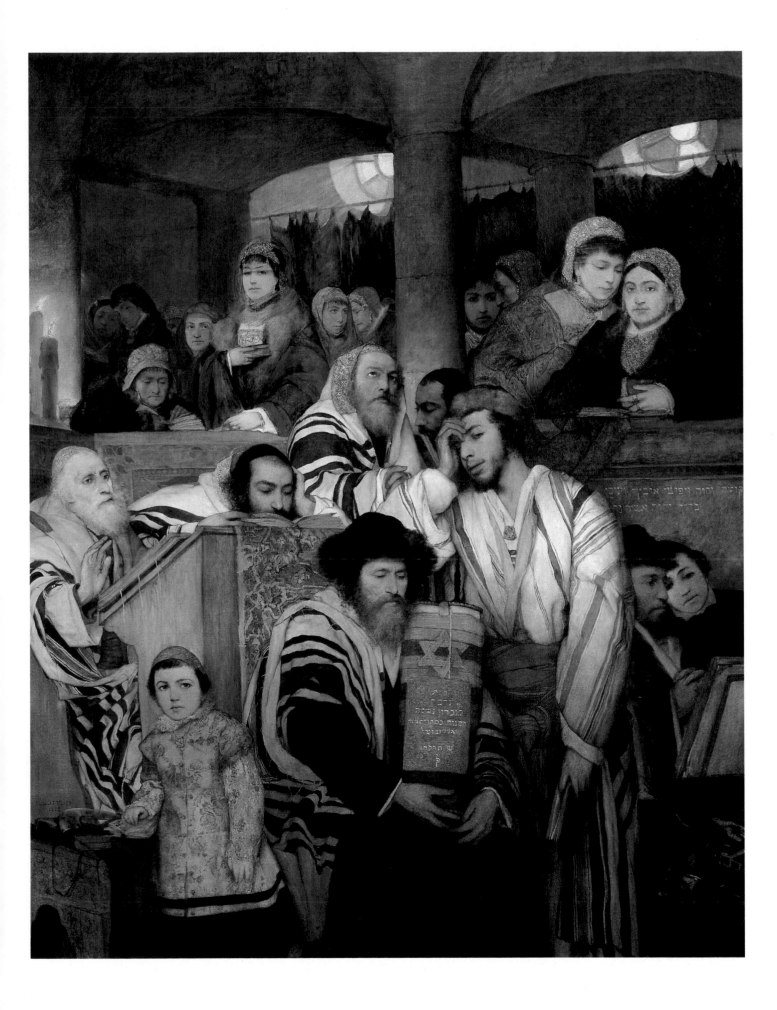

# CHAPTER FOUR
# HISTORICAL HOLIDAYS

In addition to the holidays specifically named in the first five books of the Bible, a number of special days have evolved to commemorate historic events, both the joyful and the tragic. The observances are normally less rigid for these festivals—for example, work is permitted during the course of the holiday. As with the biblical holidays, the number of associated rituals and objects depends to a large extent on the relative significance ascribed to the holiday by Jews worldwide.

Through the ages, some of these holidays have fallen into relative obscurity while others have grown in importance, such as Hanukkah, which is often now considered a major holiday. As an expression of the continuity and continually changing face of the Jewish religion, new traditions and sometimes even entirely new holidays continue to develop.

## Simhat Torah
## (Rejoicing over the Torah)

Often thought of as the last, or eighth, day of *Succot*, *Shemini Atzeret* is actually a minor biblical holiday in its own right, celebrated one day in Israel, two days in the Diaspora. It has few of its own rituals other than the reciting of the *yizkor* (the prayer for the dead) and is generally considered the conclusion to the *Succot* holiday. In Israel

**The Feast of the Rejoicing of the Law at the Synagogue in Leghorn, Italy**

*Solomon Alexander Hart R.A. (1806–1881), 1850; oil on canvas; 55 5/8 x 68 3/4 in. (141.3 x 174.6 cm). Gift of Mr. and Mrs. Oscar Gruss, The Jewish Museum, New York.* The first Jewish member of the Royal Academy in England, Hart visited many historically and architecturally important sites in Italy. This painting shows the lavish decoration of a synagogue in Livorno, Italy, and the colorful mid-nineteenth-century dress of Italian Jews as they parade the Torah scrolls on *Simhat Torah*.

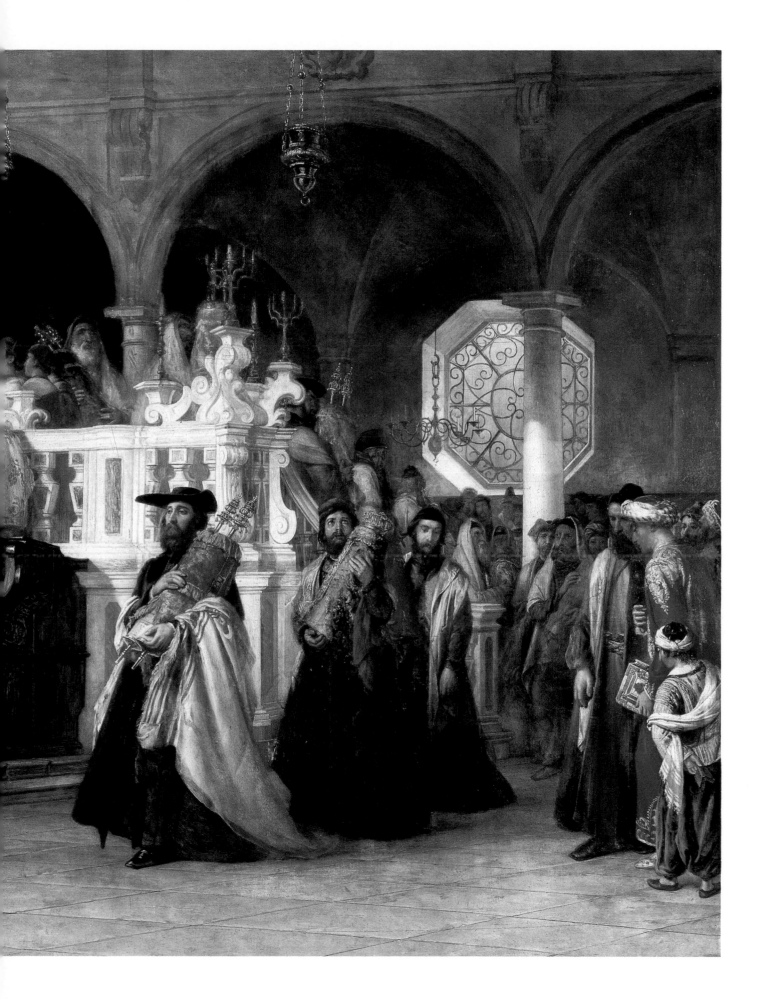

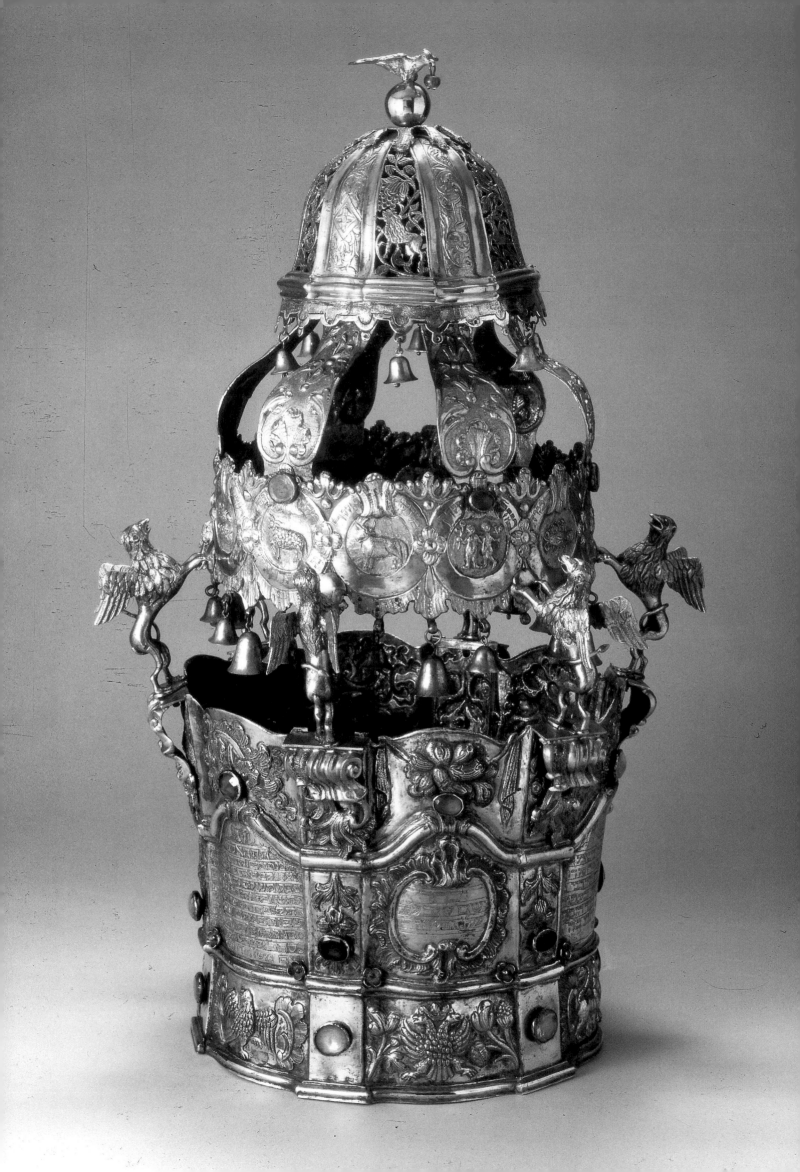

and most Reform congregations, *Simhat Torah* is celebrated on the first and only day of *Shemini Atzeret*; in the Diaspora, it is celebrated on the second day as a full holiday.

Meaning "rejoicing over the Torah," *Simhat Torah* was first celebrated in the middle ages, when the Babylonian custom of reading the full Torah (the five books of Moses) in one year was the fashion. On *Simhat Torah*, the last portion of the Torah is read repeatedly and is then followed by a reading from the first portion of Genesis. The reason for starting again immediately is so that no one should think the Torah, the essence of the Jewish religion, was being abandoned after the reading. Unlike on other occasions, both children and women in many congregations are called in groups to read from the Torah.

At the end of the readings, congregants joyfully parade the Torah around the synagogue, often accompanied by singing, dancing, handclapping, and other signs of merriment. In some Orthodox congregations, *Simhat Torah* is the only time of the year when women are allowed to enter the men's section so that they may touch or kiss the Torah as it passes. There may be several processions, called a *haffaka*, each led by a different person. In some cases, children and adults carry flags to symbolize the tribal flags under which the Israelites supposedly marched in the desert.

A joyful holiday, *Simhat Torah* demonstrates the love and reverence of the Jewish people for the Torah, the foundation of the religion. Many forms of ritual art have evolved to both protect and decorate this most sacred of Jewish texts year-round. The scrolls of the Torah are housed in a Torah ark, or cabinet, set in or against one wall of the synagogue, usually the wall facing Jerusalem, and covered with a Torah ark curtain.

The Torah scrolls are held together with a ribbon or wrapper, called a "binder," or *wimpel* in German-speaking countries, sometimes made from the swaddling cloth used in circumcision ceremonies. An excellent example of colorful Jewish folk art as well as an important historical record, a *wimpel* gives the child's name, date of birth, and the wish that he "may grow up to study Torah, to the nuptial canopy, and to good deeds."

Over the binder is placed the Torah mantle, a sheath of colored velvet or silk brocade which is richly embroidered, often in gold. Common Jewish motifs, such as the tablets of the law and the lions of Judah are used to decorate the mantle, and some also feature inscriptions. In some instances, especially in the Near East and North Africa, the Torah is protected by a silver cylindrical Torah case, sometimes called a *tik*, instead of a mantle.

From the middle ages onward, the top of the Torah was frequently adorned with a crown, most often made of silver and richly decorated with floral and animal motifs. Another form of headpiece for the Torah are *rimmonin*, the plural of the Hebrew word for "pomegranate," after which form the long finials were originally modeled. Most are made of silver, but examples of brass, wooden, and gilded pairs still exist. Almost all feature bells and are decorated with scenes from nature or traditional Jewish symbols.

## Hanukkah

Through the centuries, Hanukkah has become an increasingly popular holiday, celebrated today even by those Jews who rarely participate in other

**Oil Lamp**

*4th–5th century C.E., Israel; clay. Gift of the Betty and Max Ratner Collection, The Jewish Museum, New York.* Probably used as a Hanukkah lamp, this ancient oil lamp contains the eight compartments for each night of Hanukkah as well as a larger central hole. In ancient times, it is also possible Hanukkah was celebrated with the lighting of eight smaller individual lamps.

**Torah Crown**

*c. 1764–1773; Lemberg (Lvov), Galicia; silver: repousse, cast, cut-out, engraved, parcel gilt; semi-precious stones; glass. Gift of Dr. Harry G. Friedman, The Jewish Museum, New York.* The majesty of the Torah is emphasized by its adornment with a crown. The floral and animal motifs seen here were popular designs. As the Torah is moved, the bells, also used on *rimmonim*, ring to herald the Torah's appearance.

Jewish rituals or festivals. On the twenty-fifth day of *Kislev*, anywhere from the end of November to the beginning of January, Hanukkah commemorates the victory of the Maccabees, a historical tale known worldwide among Jews.

In 165 B.C.E., the oppressed Judeans rebelled against the Syrian-Greeks who had conquered the Jewish homeland. The Syrian-Greeks had forbidden most Jewish practices and set up a pagan cult in the Temple of Jerusalem. Under the leadership of Judas Macabaeus, the Maccabees reclaimed the Temple and cleansed it for rededication. Only a single cruse of consecrated oil remained, which should have been enough to light the seven-branched Temple candelabrum, or *menorah*, for one day. Instead, the oil lasted the eight days necessary for more holy oil to be prepared. The word *Hanukkah* means "rededication." The festival is also referred to as the "Feast of Lights," for the eight lights that are kindled as commemoration.

Although based on historical fact, the tale is not recounted in the Hebrew Bible. It does appear in the Apocrypha, a group of books included in the Greek translation of the Bible. Still, it is not until the later books of the Talmud that the miracle of the oil of Hanukkah is first written. It is likely that the festival of Hanukkah has even older associations; perhaps the lights are a remnant of ancient celebrations of the winter solstice—the shortest day of the year.

In any case, by the first centuries of this era, Jews were celebrating Hanukkah by kindling lights. Over the centuries, the lamps used have taken many forms, but they always have eight lights, one for each day of the festival. In addition, they always have a *shamash*, or servant, the first light kindled which is used to light each of the others. On the first night of the holiday, the *shamash* is used to light one light; on the second night, two are lit, and so on, until the eighth night when all eight lights burn.

In early times, the lamps were simple Roman oil lamps made of clay, stone, or ceramic. But in addition to remembering the holiday, one of the reasons for the lighting is to make the miracle known to others. Historically, Jews would do this by placing the Hanukkah lamp outside in front of the door to their homes; eventually a "bench" type of Hanukkah lamp evolved, which had a back wall that could be used to hang the lamp on a wall or to safely display the light in a window. Glass oil containers were placed in spaces carved out in the stand, which was typically raised on "legs."

In addition to safety, the back wall provided room for ornamentation and design, such as cherubs, urns, and masks. Biblical scenes were also popular, especially those of Judith carrying the head of Holophernes, a story that came to be associated with the holiday. The whole lamp became more ornate, often made of copper, bronze, or brass, sometimes incorporating designs into its very shape, with the back bench carved in the form of victorious lions, a torah, biblical scenes, or architectural designs.

Another development came about during the middle ages when the lights started to be used in synagogues for wayfarers who were not able to be home to light their own lamps. Enlarging the bench form sufficiently for the size of a synagogue did not work well and designers took inspiration from the seven-branched *menorah* in the Temple of Jerusalem. They added two lights to it to form the current eight-branched *menorah* with *shamash*. In synagogue, these were placed to the right of the Torah ark all year round, as the original *menorah* stood in the Temple.

Eventually the use of *menorahs* in synagogue led to the development of home-sized *menorahs*, which have been popular from the eighteenth century on. While the typical Hanukkah lamp has one raised light in the center to be used as the *shamash*, some lamps in Eastern Europe have twin *shamash* lamps that also allowed the lamps to be used year-round as Sabbath lamps.

Although lamps in Mediterranean countries are still commonly fueled by olive or other oils, the use of candles became increasingly popular and are now the most common for *menorahs*. In

### Hanukkah Lamp

*1787, Brody, Russia; silver, cast, repousse, applique, openwork, chased, cut-out, and parcel gilt; 27 1/2 x 16 1/2 in. (69.8 x 44.1 cm). The H. Ephraim and Mordecai Benguiat Family Collection, The Jewish Museum, New York.* Throughout the centuries, Hanukkah lamps have provided many opportunities for artistic expression. This ornate lamp is formed in the shape of a Torah ark, complete with engravings of architectural columns, floral motifs, and mythological animal representations.

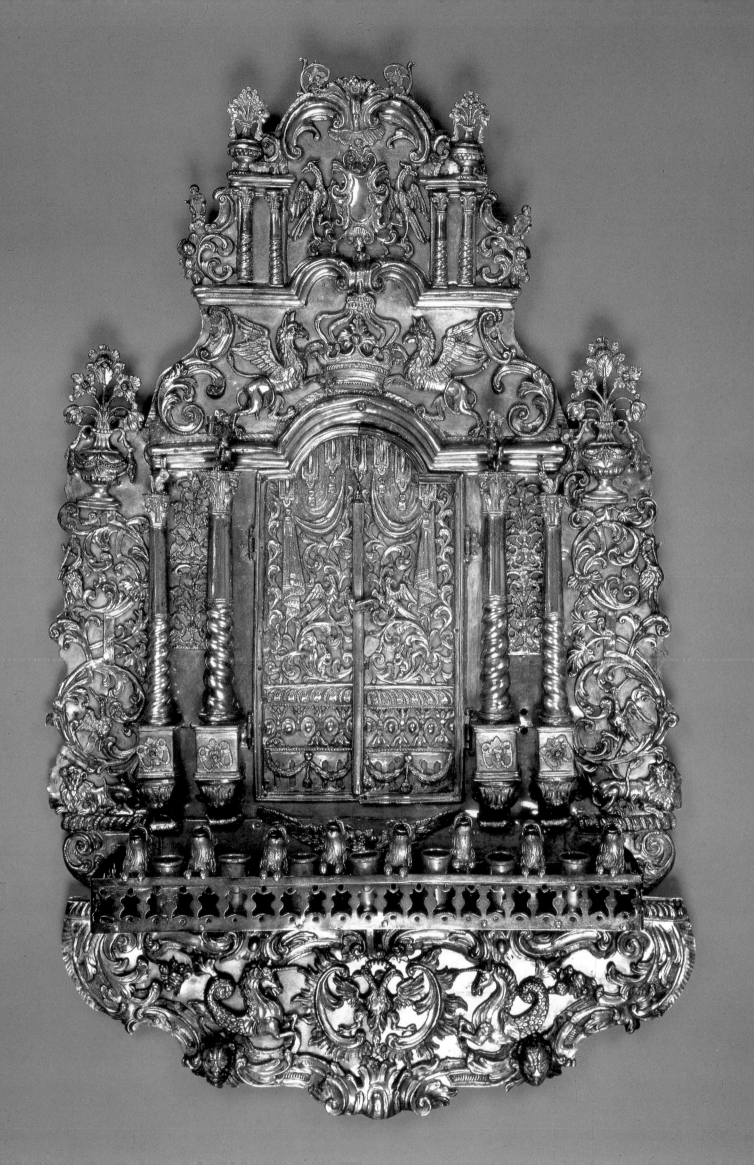

**Tree**

*Samuel Halpert, 1917; oil on canvas; 27 x 23 in.*
*(68.6 x 58. 4 cm). The Jewish Museum, New York.*
Trees have always been an important symbol to Jews, perhaps
because of their significance as a harbinger of spring. A popular
way to commemorate *Tu B'Shevat*, the New Year for Trees, in the twen-
tieth century is to contribute money for the planting of a tree in Israel.

Israel today, some modern artists have reverted to the oil form as signifying as closer connection to the ancient rituals that the holiday celebrates.

*Menorahs* today come in all forms and are made of any material that can withstand fire, from brass and silver to ceramics and glass. Virtually every Jewish home today has at least one *menorah*, typically on display all year round, and many homes have a Hanukkah lamp for each member of the family. In modern Hebrew, the lamps are called *Hanukiyah*. As one of the most easily recognizable Jewish symbols, the modern *menorah* is found on all forms of ritual art today, as was the ancient seven-branched *menorah* of Temple times, which can be seen on everything from the walls and floors of ancient synagogues to funeral art, gold glasses, coins, seals, and amulets.

As an artform, more modern *menorahs* have even captured the imagination of non-Jewish people, who are now purchasing them to light candles year round simply for their interesting designs and beauty. Another recent trend is the use of electric *menorahs*, a practice generally discouraged by rabbinic thought, but increasingly popular, in part for safety reasons. Electric *menorahs* are often used in public spaces, as well as in the windows of a Jewish home, sometimes in addition to a traditional candle or oil lamp. They tend to be unornamented, inexpensive plastic.

In addition to the lighting of the Hanukkah lamps, gift giving has developed as a modern custom. Gift giving was always part of the Purim tradition, but it was not part of the Hanukkah tradition until some Eastern European countries started the practice of giving Hanukkah *gelt* (money) on the fifth night of the festival. The strong influence of Christmas has certainly played a part in today's gift giving tradition, usually either one large gift for the whole holiday or a small gift for each night of the festival. Hanukkah *gelt* today typically comes in the form of chocolate pieces wrapped in gold foil in the shape and size of coins.

Another Hanukkah tradition is playing with the *dreidel* (a Yiddish word derived from the German word for "turn"), a four-sided top inscribed with different Hebrew letters on each of its sides. The tops are used for playful spinning as well as a game in which each player spins the *dreidel* and receives points based on the letter that appears on top. The letters stand for the Hebrew sentence, "A great miracle happened there." After the formation of Israel in 1948, some *dreidels* changed one of the letters to stand for the words, "A great miracle happened *here*." *Dreidels* are typically made of plastic or wood.

## Tu B'Shevat (New Year for Trees/Arbor Day)

One of the four traditional "new year" celebrations of the Jewish calendar, *Tu B'Shevat* celebrates the "new year" for the trees, more commonly called "Arbor Day" in English. (The other "new years" are *Rosh Hashana*, the beginning of the Jewish religious year; the first of *Nisan*, the first month of the Jewish calendar; and the first of *Elul*, for tithing of animals.) The holiday is a holdover from the Temple days, when the fifteenth of *Shevat*, in the early spring, was the day associated with the assessment of the fruit crop to determine what portion was due to the Temple.

In Talmudic times, Hillel and his disciples declared the day a holiday, using the name "Rosh Hashana L'Ilant" ("New Year for Trees") because by this day in Israel the annual rains have ended and a new cycle for tree growth has begun. The "Tu" in the name "Tu B'Shevat" derives from the Hebrew letters *tet* and *vav*, which together have a numerical value of fifteen and marks the day of the month *Shevat* on which the holiday is celebrated.

A relatively minor holiday, the day became a time to celebrate the connection of the Jews with the Holy Land and grew in importance in the twentieth century with the reemergence of the State of Israel. The most common observance of the day was the eating of fruits associated with the land of Israel, especially pomegranates. Some eat almonds, because they were the first to blossom of all the trees in Israel, and others turned to *bokser* or carob, because it was able to survive the long trip from Israel to Jews throughout the world. In Israel today, children go on field trips to plant trees, while those outside of Israel often contribute money to plant a tree.

There is not much art specifically associated with the holiday, a relatively minor one in the context of other Jewish observances. The themes of trees and fruits, however, especially those that grew in ancient Israel, are often found on items of importance of all ages, ranging from plates and scrolls to *ketubot* and mosaic floors.

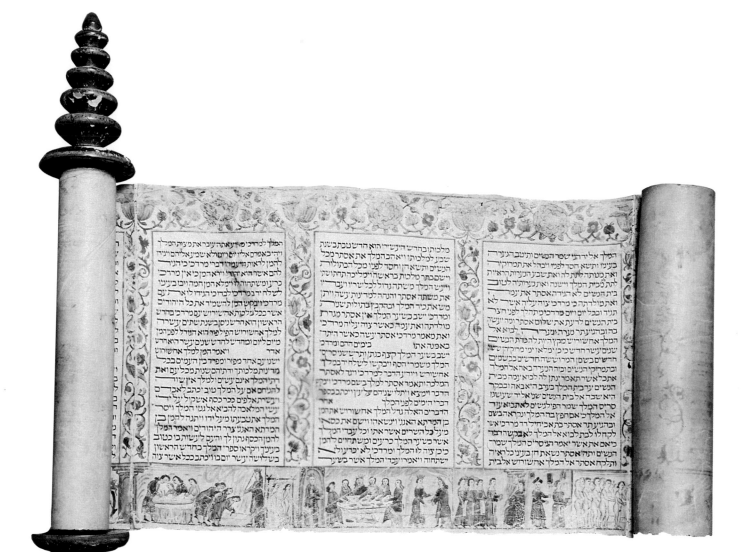

### Esther Scroll

*1708, Corfu; ink and*
*tempera on parchment;*
*46 3/4 x 10 1/4 in.*
*(120 x 26.5 cm).*
*Israel Museum, Jerusalem.*
Because the Book of Esther
does not include the name
of God and is normally
written in the form of a
scroll called a *megilla Esther,*
it became the only book of
the Bible traditionally deco-
rated with human figures.

### Purim

Like Hanukkah, Purim is a minor holiday
connected to a historical event. It occurs in the
early spring in the month of *Adar*, and com-
memorates the escape of the Jews from destruc-
tion in the fifth century B.C.E. as related in the
Book of Esther.

The dramatic story unfolds around Esther, who
has won a beauty contest and become the wife of
the King of Persia, Ahasuero. Her cousin
Mordechai has learned that Haman, a courtier of
the king, has drawn lots (*purim*) to determine the
day on which he will exterminate all the Jews in
the Persian empire. At the risk of her own life,
Esther reveals herself as a Jew to the king and tells
him of Haman's plot. The king nullifies the decree
and the Jews turn on their enemies and avenge
themselves. Haman and his sons are hung on the
gallows originally prepared for Mordechai.

A number of inconsistencies between the story
and history as it is known have led scholars to

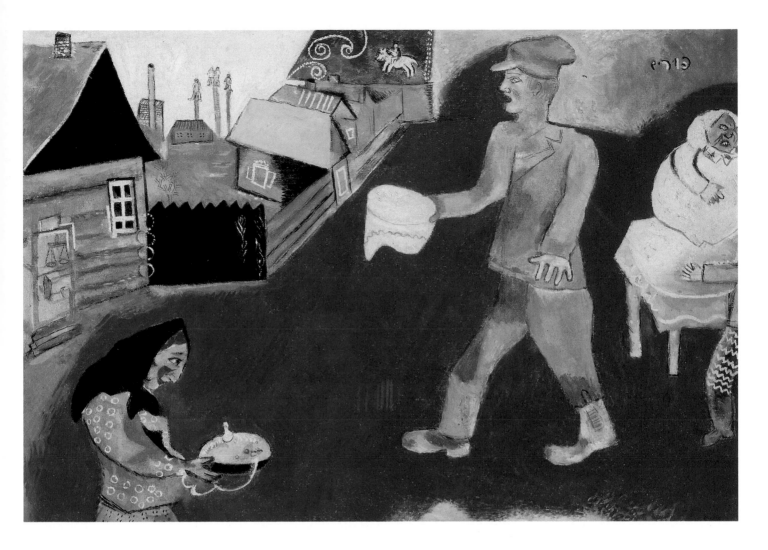

question the literal truth of the story and to the conclusion that the festival is most likely a transformation of an ancient pagan custom. History or not, the story has resonated with Jews throughout the ages, affirming the bright moments in their checkered history when Jews have successfully defeated persecution.

The Book of Esther is unusual in several ways, particularly in the omission of the name of God anywhere in the story. Another peculiarity is that the story is often in the form of a scroll, rather than an actual book, based on the idea that the story was sent out to all parts of the kingdom in a scroll form. The scroll is called a *megillah*. These two oddities combined to give Jewish artists much greater freedom in decoration than with other books of the Bible, and the *megillah* became the only biblical book traditionally accompanied by pictures.

In addition to the scrolls handwritten in black ink for use in the synagogue, many families had their own *megillah*, often decorated or illuminated. The *megillot* of Italy from the sixteenth to the eighteenth century are considered particularly fine, and come in a variety of styles. Some are decorated with floral, geometric, and scrollwork patterns above and below the text. Others feature scenes from the story itself. Still others use ornate architectural pillars and other elements to frame columns of Hebrew script.

The scrolls themselves were often kept in cases made of carved wood or decorated silver, commonly illustrated with scenes from the Book of Esther. These containers were a popular gift from the bride to the bridegroom.

Overall, the holiday has a Mardi Gras feel to it that is unique to Jewish holidays. Even in synagogue, where the most joyous occasions are traditionally tempered with a sense of the solemn, congregants drown out the name of Haman every time it is uttered by stamping their feet or swinging rattle-type noisemakers called *groggers*.

**Purim**

*Marc Chagall (1887–1985), 1916–1918; oil on canvas; 19 7/8 x 12 1/4 in. (50.5 x 31.1 cm). Philadelphia Museum of Art, Philadelphia.* Inspired by childhood memories of his wife, Bella, Chagall set this Purim celebration in a typical Russian village. The children bear gifts of food for friends, family, and neighbors.

And Purim is certainly the only Jewish holiday where Jews are instructed in the Talmud to get so drunk that they are not able to tell the difference between "Blessed be Mordechai" and "Cursed be Haman"!

Other traditions have evolved in accordance with the instructions in Esther 9:22: "They were to observe them as a time of feasting and gladness, and as a time for sending gifts to one another and presents to the poor." A day of fun and parody, Purim is the one time of year when Jews make fun of all that is normally sacred, even making up nonsensical prayers and satirizing the Talmud. Masquerade parties are popular for both adults and children.

The custom of giving gifts survives today among some Jews, who send friends cakes, fruits, and *hamantaschen*—a German word meaning "Haman's pockets"—triangular pastries filled with either fruit, cheese, or poppy seeds. While these gifts are most often sent on paper plates now, in the past special plates were used, often made of pewter and decorated either with quotations or scenes from the Book of Esther, especially the Triumph of Mordechai. Some congregations also had special collections cups used only for Purim.

## Tisha B'Av and Other Fast Days

The Jewish calendar is marked by a number of fast days, the most important of which is the biblical holiday *Yom Kippur*, when Jews atone for their sins of the previous year in order to start the new year with a clean slate. Second in importance is *Tisha B'Av*, the ninth day of the month of *Av*, which is like *Yom Kippur* in that the fast goes from sundown to sundown.

*Tisha B'Av* commemorates many of the tragedies of Jewish history, beginning with the destruction of the Temple by the Babylonians in 586 B.C.E. The second Temple is said to have been destroyed by the Romans on the same date in 70 C.E., an event that marked the end of Jewish sovereignty and the beginning of exile until the founding of Israel in this century.

Other events also said to have happened on the ninth day of *Av* include the golden calf incident at Mount Sinai; the fall of Betar, the last Jewish stronghold during the Bar Kochba rebellion against Rome in 135 C.E.; the expul-

sion of the Jews from England in 1290 C.E.; and the beginning of the expulsion of the Jews from Spain in 1492 C.E. A fast marks the day, and in synagogue, Jews sit barefoot on low benches, traditional mourning customs. Although historically an important day, *Tisha B'Av* tends only to be celebrated by more observant Jews these days.

A number of other minor fast days are also associated with the fall of the Temple and Jerusalem. A minor fast is observed only from sunrise to sundown and is not accompanied by other rituals. *Shiva Asar B'Tammuz*, the seventeenth day of *Tammuz*, three weeks before *Tisha B'Av*, marks the day when the Babylonians first breached the walls of Jerusalem before the Temple's destruction. A three-week period of semi-mourning occurs between the fast on this day and the fast of *Tisha B'Av*.

The Fast of Gedaliah on the third day of *Tishri* (following the second day of *Rosh Hashana*), remembers the assassination of Gedaliah, the Jewish official appointed to govern the Jews after the destruction of the temple in 586 B.C.E. He was posthumously considered a hero for his efforts to rebuild Jewish life. *Asara B'Tevet*, the tenth day of *Tevet*, the month after Hanukkah, marks the beginning of the siege of Jerusalem in 588 B.C.E. Most of these minor fasts are not observed today by any but the most Orthodox Jews.

Two other minor fasts not related to the destruction of the Temple include *Ta'anit Esther*, or the Fast of Esther, on the thirteenth day of *Adar*, which was established in the eighth century C.E., and *Ta'anit Bekhorim*, the Fast of the Firstborn, observed the day before Passover by firstborn children (including women) to celebrate being spared the plague of the firstborn at the time of the Exodus. Again, neither of these two fasts is generally observed today.

As relatively minor holidays, most of these fast days have not been the subjects of artistic endeavors. However, the drama of the tragedies they commemorate—particularly the destruction of the Temples, the golden calf at Mount Sinai, and the expulsion of the Jews from Spain—have often been immortalized in paintings and other art, both by Jews and non-Jews.

### Nehemiah Looks Upon the Ruins of Jerusalem

*James Jacques Joseph Tissot (1836–1902); oil on canvas;*
*9 1/4 x 7 1/2 in. (23.6 x 18.9 cm). The Jewish Museum, New York.*

After hearing of the destruction of Jerusalem and the Temple by the Babylonians in 586 B.C.E., Nehemiah,
cup bearer to King Artaxerxes I, decided to rebuild the city walls. Here he surveys the ruins with distress.
Tissot's familiarity with Jerusalem and its history is evident in the accurate depictions of the buildings.

**Jerusalem**

*Anna Ticho (1894–1980),*
*1969; charcoal on paper;*
*27 5/8 x 39 1/2 in.*
*(70 x 100 cm). The*
*Museum of Modern Art,*
*New York.*

Born in Austria, Ticho
moved to Jerusalem in
1912. The ancient hills,
rocks, and olive trees
around Jerusalem provided
inspiration for her work,
as they have for artists
throughout the ages.

## Twentieth-Century Holidays

In the twentieth century, a number of momen-
tous events occurred that would change the face
of Judaism worldwide. As a living, evolving reli-
gion, Judaism has incorporated some of these
events into its very structure, creating new holi-
days and new forms of artistic expression to
commemorate such events.

The twenty-seventh day of *Nissan*, shortly after
Passover, was chosen by the Israeli Knesset to
remember all those who died under Nazi
oppression. Unlike other holidays, Holocaust
Day (*Yom Ha-shoa*) was brought about by a gov-
ernment body, not by rabbinic authority and
does not yet have many rituals associated with it.
In Israel, there are wreath laying ceremonies at
Yad Veshm, the Jerusalem memorial to Nazi vic-

tims, and many places of business, schools, and
banks are closed.

Another new holiday is Israel Independence
Day (*Yom Ha-atzmaut*), which occurs on the fifth
day of *Iyyar* to celebrate this day in 1948 (May
14) when Israel became a state. Israel had not
been an independent nation since the Second
Temple was destroyed by the Romans in 70 C.E.
The day is preceded by a remembrance of those
who died fighting for Israel, when it is common
to light candles and visit graves, and a torch is lit
for twenty-four hours. The sorrow then turns to
joy with parades, parties, and other festivities on
the holiday itself.

The third new holiday is Jerusalem Day (*Yom
Yerushalayim*), which takes place on the twenty-
seventh day of *Iyyar*, when in 1967, the two sec-

tions of Jerusalem were reunited after the Israeli victory over the Arab armies during the Six-Day War. This day marks the first time that the Temple Mount and the Western ("Wailing") Wall were under Jewish control since the destruction of the Temple in 70 C.E. The day begins with a thanksgiving service at the Western Wall when torches are lit in memory of the Israeli soldiers who died in the battle for Jerusalem.

Other than the special prayers that most Reform and Conservative congregations add on these days, these holidays have few rituals associated with them, perhaps because they are still so new. Jews worldwide continue to try to come to terms with the almost-simultaneous tragedy of the Holocaust and fulfillment of the centuries-old dream of Israel, expressed poignantly in the line Jews still recite every year at the Passover *seder*: "Next year in Jerusalem."

The events of the twentieth century have been the spark for numerous artistic expressions, particularly paintings and a new Jewish interest in sculpture. In Israel, public sculptures depict the most important events of the Jewish state and Jews worldwide. Some artists apply new principles to ancient forms of ritual art, creating a unique synthesis of form and function.

As Jewish artists struggle to understand recent events and the changing role of Judaism, they increasingly use techniques from a range of artistic styles. Both recent and ancient events are examined and depicted in new lights, while the ever changing faces of Jewish people and communities continue to provide inspiration.

**Miracle II**

*Jacques Lipchitz (1891–1973), 1947; bronze; 30 1/2 x 14 in. (77.4 x 35.5 cm). The Jewish Museum, New York.*
Lipchitz, who escaped from Nazi-occupied France to the United States in 1941, often worked with the themes of survival and redemption. Created a year before the state of Israel became official, this sculpture shows the ancient tree of life, the *menorah*, and a man intertwined, all three giving sustenance and support to each other.

**Purim Grogger**

*19th century, Russia; silver.*
*The Jewish Museum, New York.*
During the reading of the *Megilla Esther* (the book of Esther) in synagogue on Purim, congregants turn noisemakers called *groggers* to drown out the name of Haman, who has come to symbolize the various enemies of the Jewish people throughout the centuries. His crimes were punished by hanging, as depicted here.

**Torah Crown for Simhat Torah**

*Mid-19th century, Alsace; papier mache, silk ribbons,*
*cardboard, paper; 8 1/4 x 7 1/4 in. (21 x 18.5 cm).*
*Jüdisches Museum der Schweiz, Basel.*

Some congregations highlight the importance of
*Simhat Torah*—when the yearly reading of the five
books of Moses finishes and begins again—with special
Torah decorations and ornaments such as this crown.

**Torah Case**

*1568; Damascus, Syria; brass: chased, pierced, silver-inlaid, cast; 25 1/4 x 7 in. (64.1 x 18 cm). The Jewish Museum, New York.*

A tradition popular among North African, Near Eastern, and Asian Jews is to protect the Torah in a cylindrical case, called a *tik*, rather than by wrapping it in a mantle. When the case is opened, the Torah can be read without removing it.

**Hanukkah Lamp**

*Johann Valentin Schuler; c. 1680; Frankfurt-am-Main,
Germany; silver, gilt; 10 x 12 1/4 x 2 3/4 in.
(25.1 x 31.1 x 7 cm). The Jewish Museum, New York.*
The bench-type of Hanukkah lamp, with its large
back wall, legs, and smaller front piece, allowed
artists numerous possibilities for decorative
ornamentation, especially of animal and biblical
figures, such as Judith, associated with the holiday.

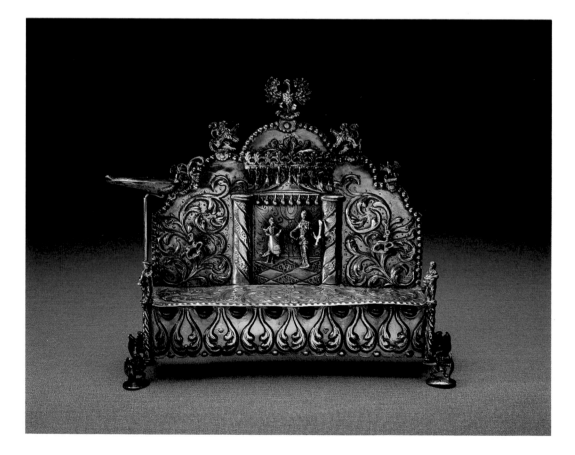

**Pomegranates**
*Franz Bernheimer (b. 1911), 1962; brush and ink;*
*24 1/2 x 34 1/4 in. (62.5 x 88 cm). Israel Museum, Jerusalem.*
Indigenous to Israel, the pomegranate is one
of several traditional fruits eaten at the time of
*Tu B'Shevat* to commemorate the "new year" for trees.

*Following Page:*
**Triumphal Arch of Titus**
*81–96 C.E., Rome; stone.*
This relief shows part of the triumphal
procession when Jewish prisoners of war were
forced to carry objects taken from the Temple,
including the *menorah*, after Rome's victory in 70
C.E. Despite the many legends that developed, the
whereabouts of the ancient *menorah* are unknown.

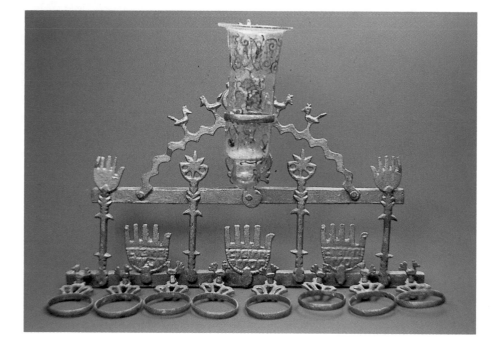

**Hanukkah Lamp**

*18th century, Baghdad; brass, glass oil containers;*
*18 3/4 x 8 1/2 in. (48 x 22 cm). Israel Museum, Jerusalem.*
This Hanukkah lamp from the Near East includes many
elements of Islamic art, such as the birds, crescent and star,
and the hand for protection against the "evil eye." The
glasses were filled with water, then oil, which floated on
the top. A wick absorbed the oil to produce the flame.

## Hanukkah Lamp

*Peter Shire, 20th century (American). The Jewish Museum, New York.*
Modern Hanukkah lamps can take many forms, such as this whimsical
twentieth-century lamp. The brightly colored geometric shapes provide five
of the candle holders, while the other three candles are placed in the cylinders
on the round piece. The holder for the *shamash* is set off from the others.

## Plate for Tu B'Shevat

*19th century, Austria; glazed pottery;*
*10 3/4 in. diameter (27.5 cm). Israel Museum, Jerusalem.*
The focal point of this special plate for *Tu B'Shevat* is
the trees and fruits common to Israel. The Hebrew
around the plate gives the date of the holiday, while the
words in the center are the blessing for eating the fruit,
one of the ways the holiday is typically celebrated today.

## Purim Plate

*18th century, Les Islettes (Meuse); faience. Musée de Cluny, Paris.*
Special plates, such as this decorated earthenware dish, evolved in
keeping with the custom of giving gifts of sweets to friends on Purim.
The inscription around the sides quotes the instructions to send gifts
to one another from the Book of Esther. The picture portrays the
humiliation of Haman by Mordechai, also from the Book of Esther.

**The Hebrew Purim Ball at the Academy of Music**

*1865, New York; illustration. American Jewish*
*Historical Society, Waltham, Massaschusetts.*
The Purim Ball held March 14, 1865 at the Academy of
Music in New York was an extravagant example of the
masquerade parties common to celebrate the merry holiday.
On the right, a party-goer is dressed as a Hanukkah *dreidel*.

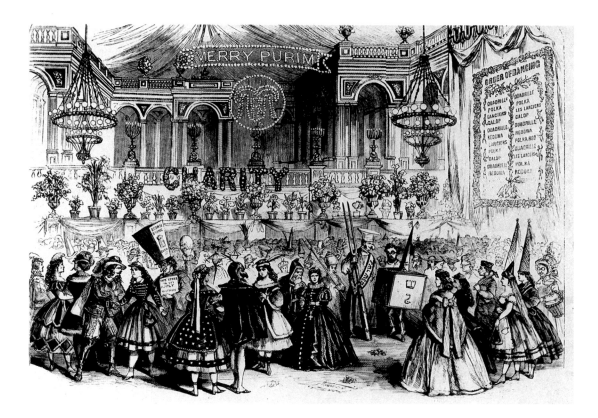

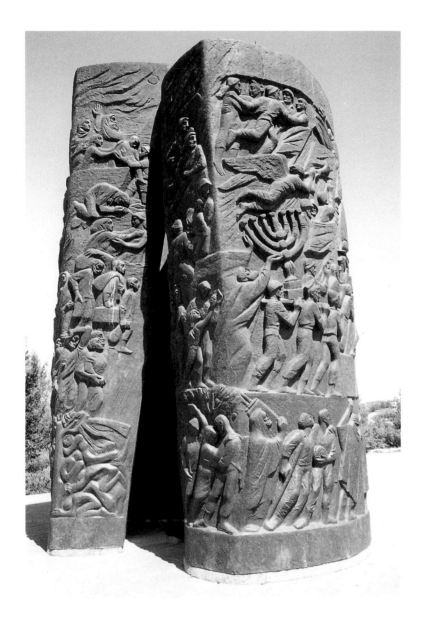

### Scroll of Fire

*Nathan Rappoport (1911–1987). 1977; bronze public monument;*
*26 ft. (7.9 m). Kesalon, Israel. Photograph by James Young*

In the form of a huge scroll in the Judean hills overlooking Jerusalem, one
side of this monument laments the tragedy of the Holocaust while the other
celebrates the creation of the state of Israel. Rappoport included scenes
from major events of the time, beginning with the Warsaw Ghetto Uprising.

# INDEX